THE UNTRUE HISTORY OF ART

PETER DUGGAN

For Zoë and Grace

First published by Duggoons in 2020

ISBN 978-1-8382557-0-1

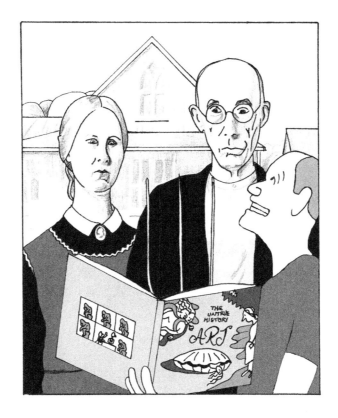

They're right, it's hysterical. *The Untrue History of Art* is a rollicking riff on art history in 125 cartoons.
Based on the popular Guardian cartoon strip *Peter Duggan's Artoons*, *The Untrue History of Art* is an expanded version
of a previous volume published by Virgin Books, also called *Peter Duggan's Artoons*.

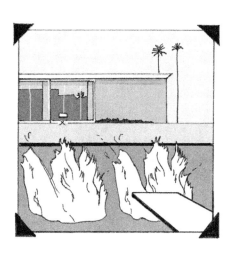

LIFE OUTSIDE THE STUDIO

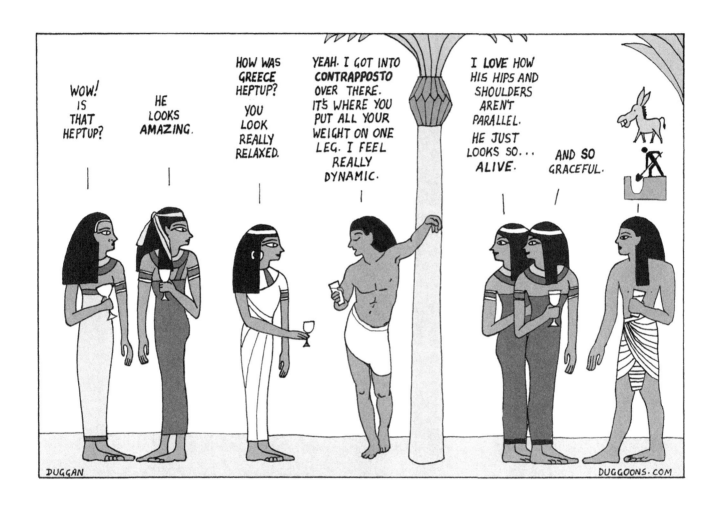

With the invention of contrapposto, the ancient Greeks were rebelling against the very stiff, static look of earlier sculpture, which they found really nerdy. It is hard to imagine a Greek statue staying at home on a Saturday night. There are many sculptures of Apollo smoking a cigarette for example. Not only did the ancient Greeks paint their statues but there is mounting evidence that they clothed them as well. A statue of Hermes was recently found wearing a leather jacket. Experts are still debating whether a pair of jeans found on a statue of Heracles had decayed over time or were ripped from the start. No belt was found which suggests the jeans hung low, revealing his underpants. So cool.

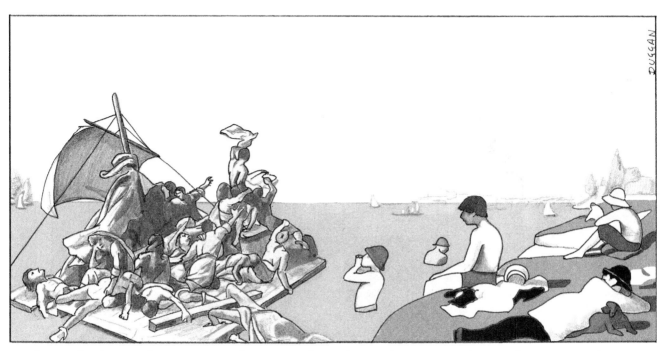

Though they often spent their weekends at the same riverside spot in Paris,
the Pointillists and the Romantics rarely socialised.
The Romantics found the Pointillists to be quite unhelpful, while the Pointillists
thought the Romantics were a bunch of attention-seeking drama queens.

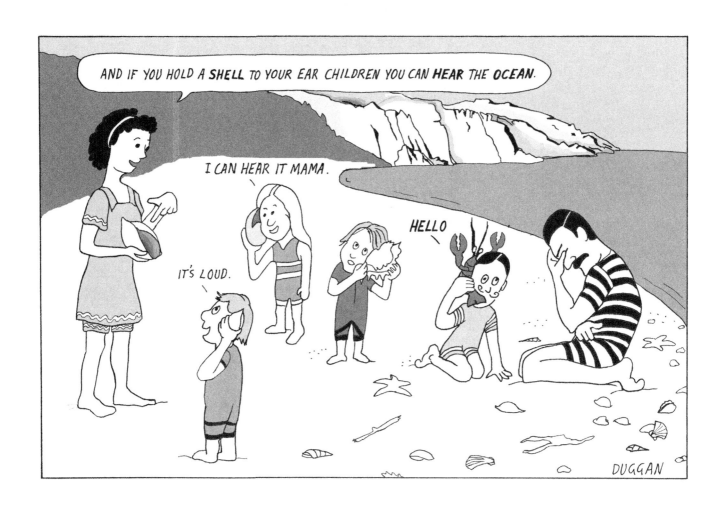

Cartoonist's dilemma – how to show that the kid with the lobster is Salvador Dali? Easy! Just put the iconic Dali moustache on his 4 year old face.

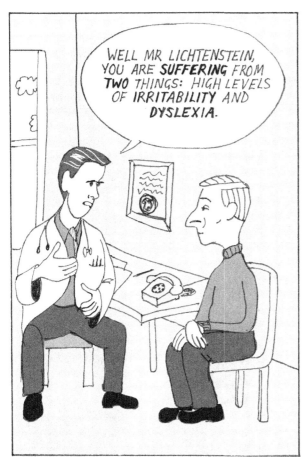

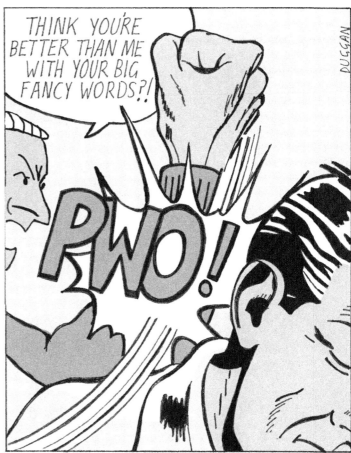

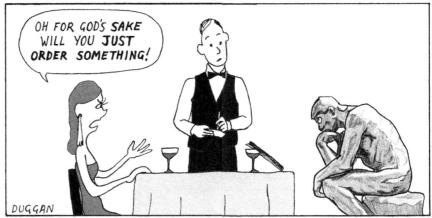

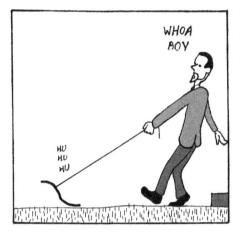

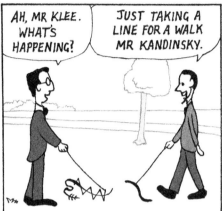

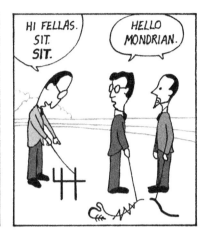

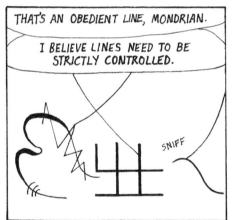

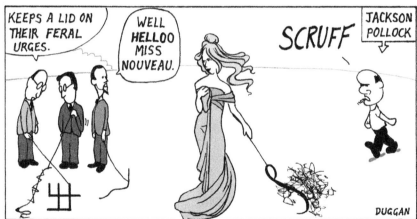

Paul Klee once described drawing as "Taking a line for a walk". Such a great line.

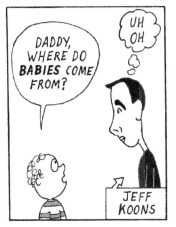

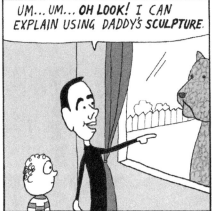

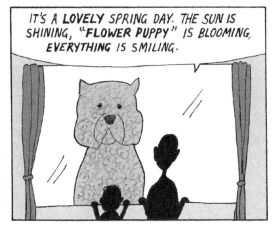

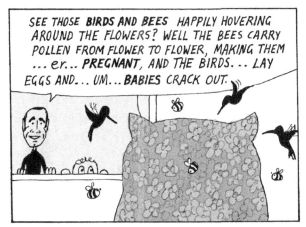

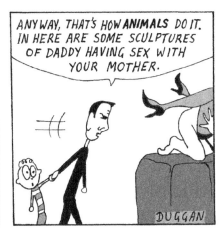

Oh Jeffrey. He has made a lot of kitschy stuff, as well as some quite pornographic stuff with his former wife, the porn star Cicciolina. That combination makes him comic gold.

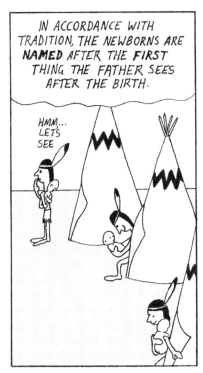
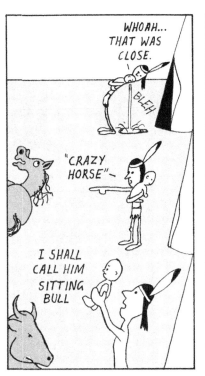
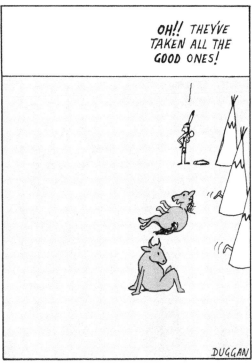

For some reason Chuck Close never really earned the respect of the tribe.
Eventually, he gave up his dream of becoming a fierce warrior leader
and did an arts degree.

This is the normal route to becoming a photo realist.

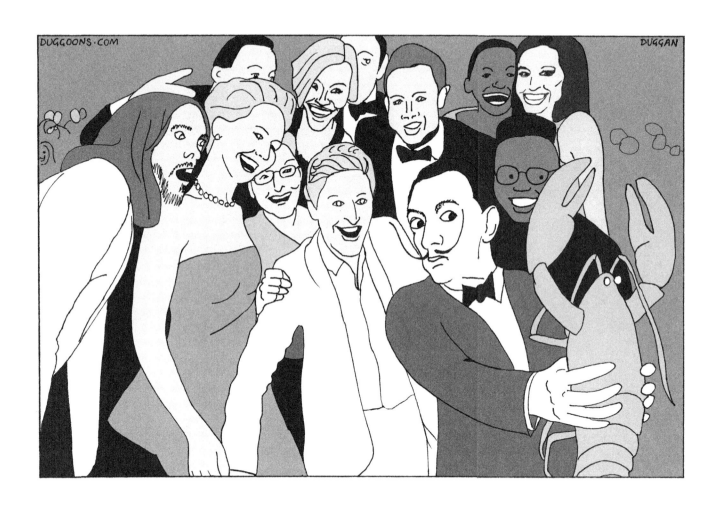

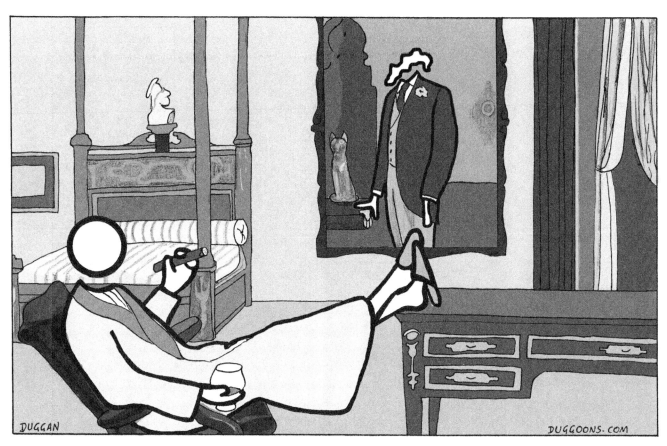

The Picture of Dorian Opie

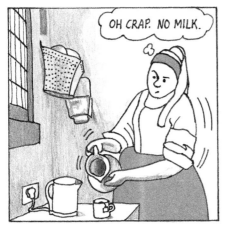
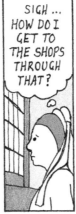
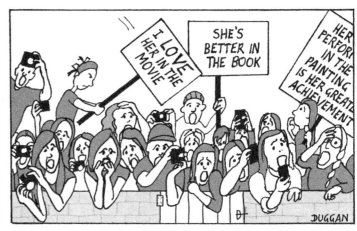
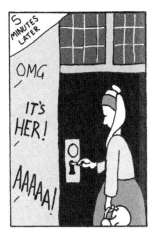
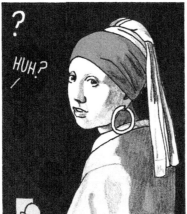
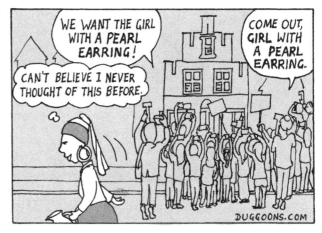

Interesting how fashions change. When I was young, *The Milkmaid* was the iconic, cliche Vermeer, much like what *The Scream* is for Edvard Munch. *Girl With The Pearl Earring* was thought a minor, though ravishing picture in his oeuvre. The novel by Tracy Chevalier, and later the film, shifted that somewhat. A friend of mine, a writer of genius, asked me to read his new manuscript about Munch's overlooked painting *The Cough*. It's rubbish.

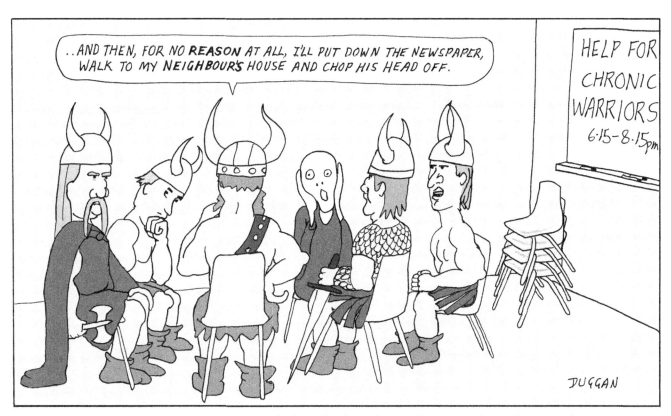

Joining a support group didn't help. If anything, Edvard Munch's chronic worrying just got worse.

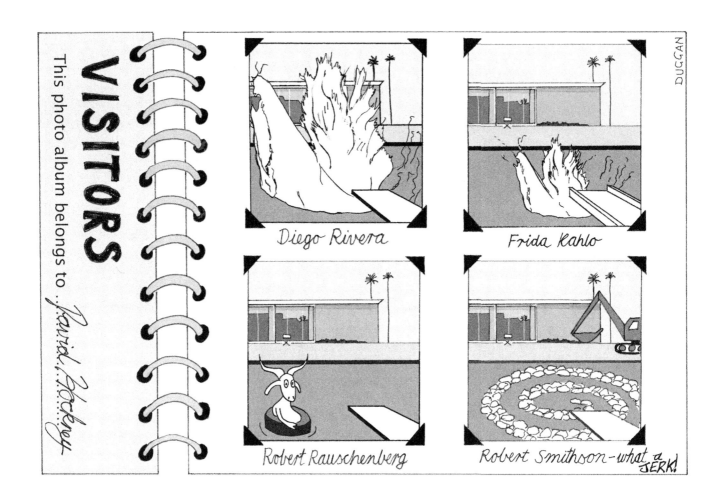

DUGGAN

VISITORS

This photo album belongs to ... *David Zackley*

Diego Rivera

Frida Kahlo

Robert Rauschenberg

Robert Smithson — what a JERK!

I could explain the references here, which may be unfamiliar, but it would be the equivalent of explaining the joke. So this is a great place to reiterate that I have helpfully created, not one, but two indexes at the back of this book. The first is by page number, listing both the artist(s) and artwork(s) appearing in each particular cartoon; the second by artist name. This, combined with Google, is my educational gift to you. If you can't be bothered then trust me, it's funny. Laugh emptily and move on.

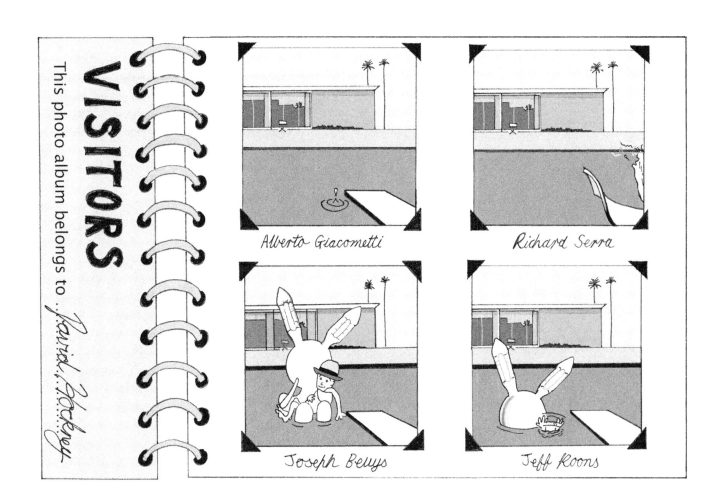

VISITORS

This photo album belongs to ..David Hockney

Alberto Giacometti

Richard Serra

Joseph Beuys

Jeff Koons

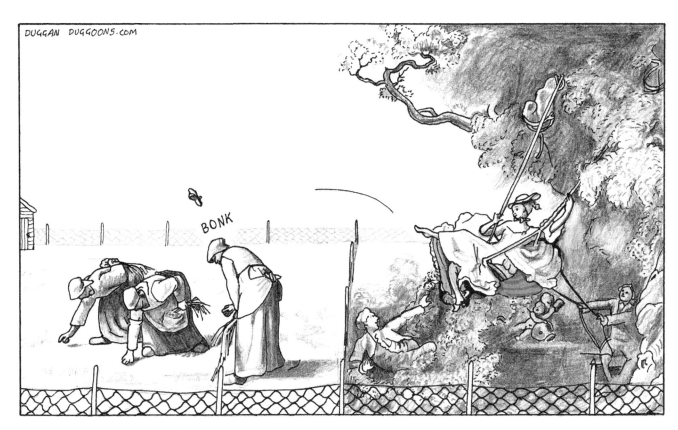

Almost invariably, allotment gardening fosters a really positive community spirit.
Causing the French Revolution was a total blip.

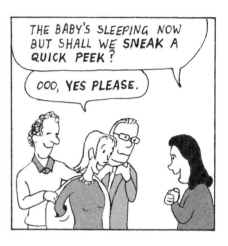

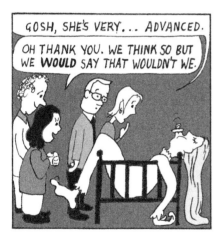

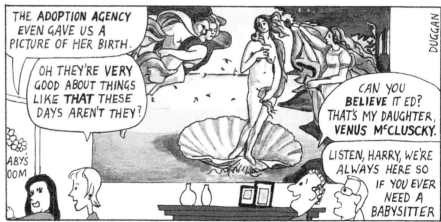

In case you were unaware, Venus was the most beautiful being in existence. Perhaps she still is, although she will have aged a lot, especially considering she was born an adult.

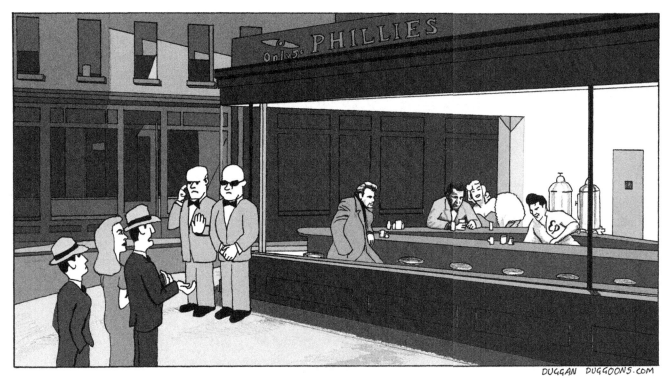

Edward Hopper's paintings are renowned for their powerful sense of alienation.

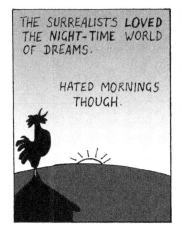

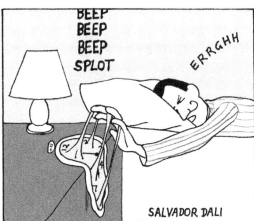

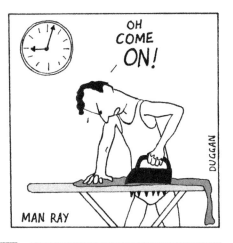

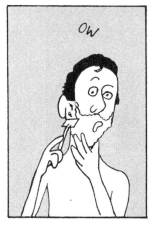

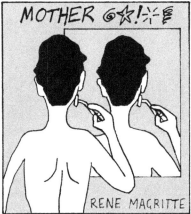

REVEALED!

CRIMINAL RECORDS OF ART WORLD STARS

VENUS DE MILO
ATTEMPTED ARMED ROBBERY

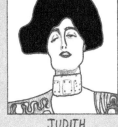

JUDITH
OBTAINING PROPERTY BY DECEPTION

LEDA
UNLAWFUL ACT ON AN AIRCRAFT

PABLO PICASSO
DISORDERLY CONSTRUCT

JANE DOE
SERVING ALCOHOL TO A MINOR

TOULOUSE-LAUTREC
FAILURE TO PRODUCE PROOF OF AGE ON A
LICENSED PREMISES, UNDERAGE DRINKING,
SWEARING AT A POLICE OFFICER,
RESISTING ARREST

DUGGAN DUGGOONS.COM

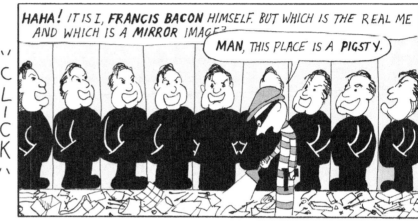

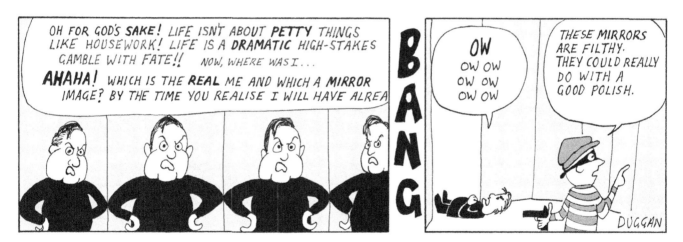

Drama seems to have been the essence of Bacon, both in his work and his life. And if you have seen photos of his studio, housework obviously held little dramatic appeal.

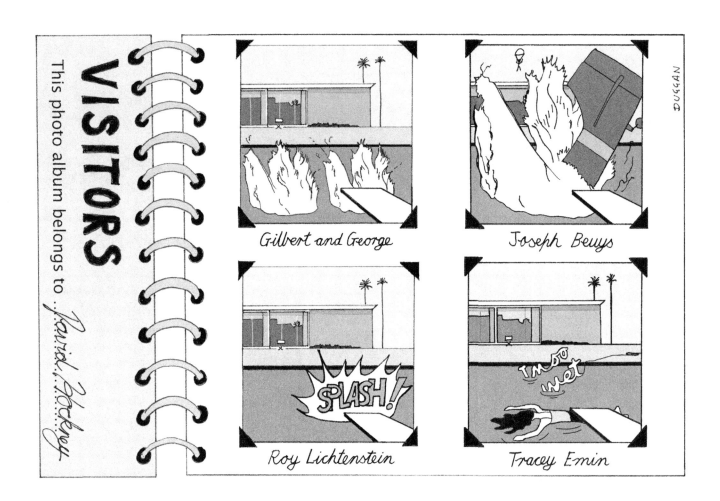

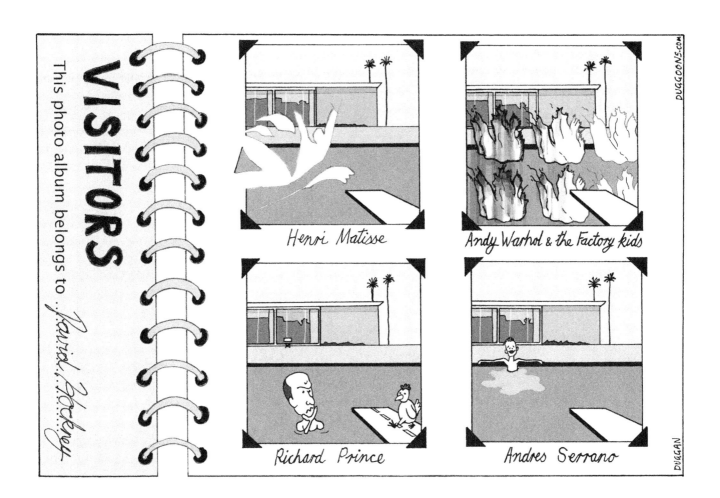

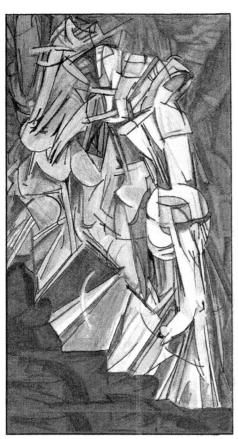

Nude Descending a Staircase

DUGGAN

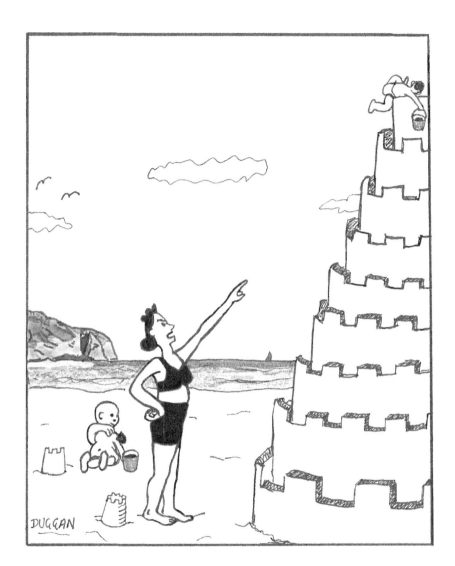

Anselm Kiefer, aged 3.

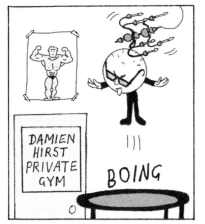

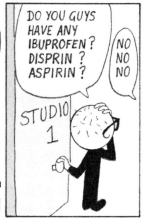

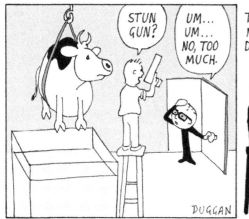

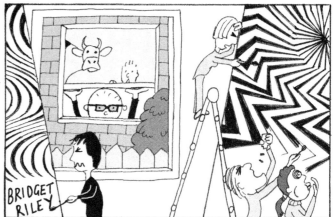

THE ART DOCTOR DIAGNOSES THE NUDES OF FAMOUS ARTISTS

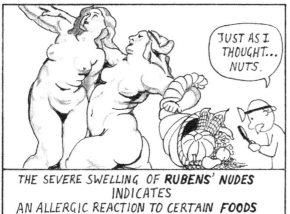

THE SEVERE SWELLING OF **RUBENS'** NUDES INDICATES AN ALLERGIC REACTION TO CERTAIN **FOODS**

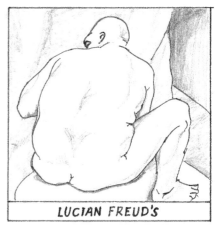

LUCIAN FREUD'S

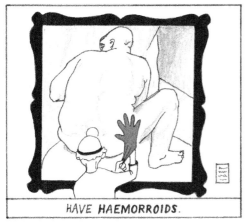

HAVE **HAEMORROIDS**.

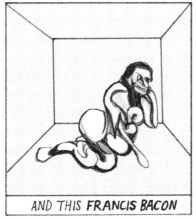

AND THIS **FRANCIS BACON**

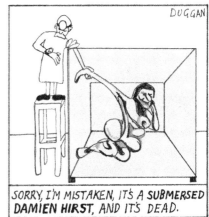

SORRY, I'M MISTAKEN, IT'S A **SUBMERSED DAMIEN HIRST**, AND IT'S DEAD.

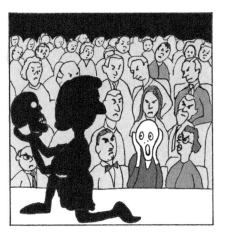
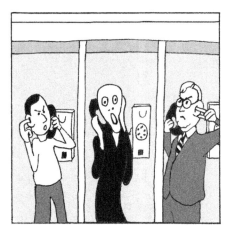
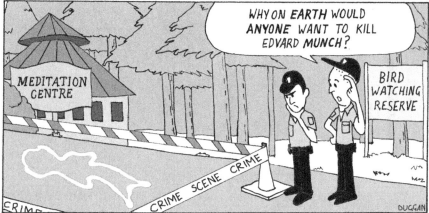

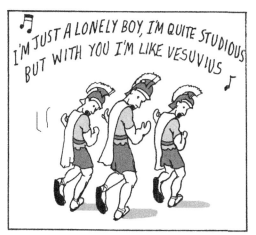

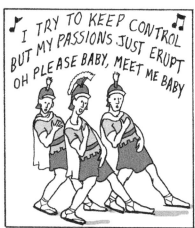

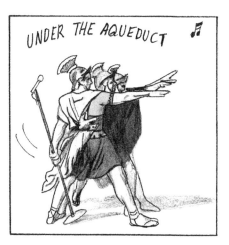

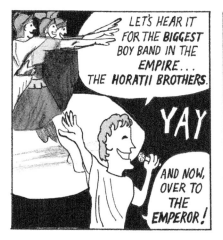

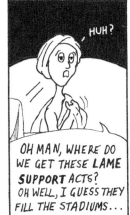

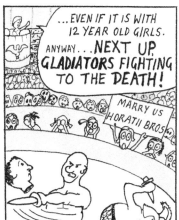

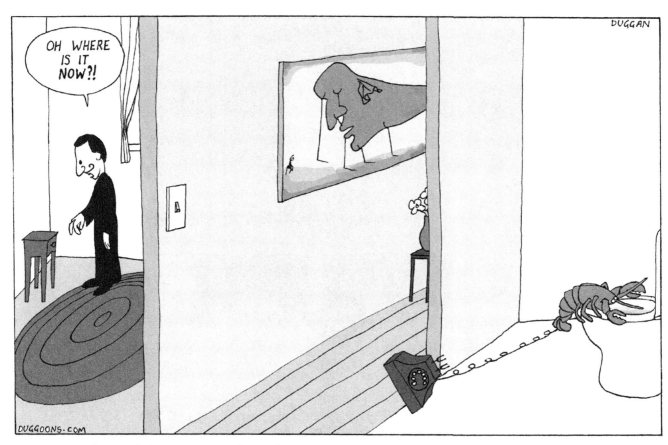

Dali couldn't comprehend why anyone would want a mobile phone.

There are some artworks with seemingly limitless comic potential. Actually, I think they all do, but with some the tap is open wide. Salvador Dali's "Lobster Telephone", an old fashioned telephone with a lobster as the handset, is certainly one of those, and consequently I took several cracks at it. After a while I had to stop.

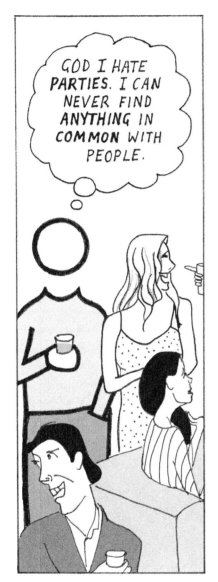
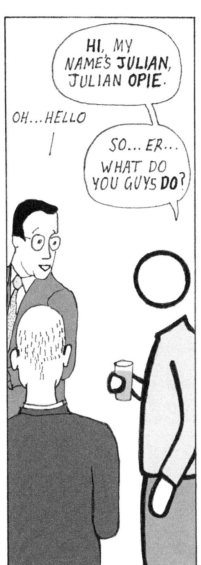

ON THE JOB

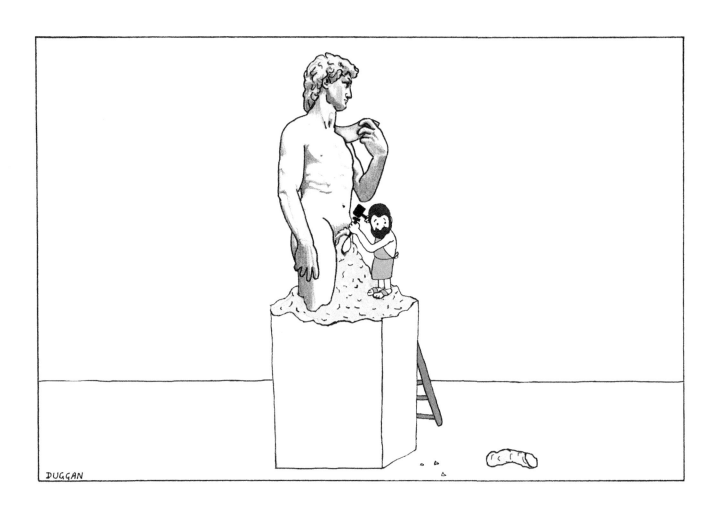

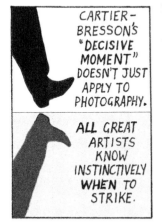

CARTIER-BRESSON'S "DECISIVE MOMENT" DOESN'T JUST APPLY TO PHOTOGRAPHY.

ALL GREAT ARTISTS KNOW INSTINCTIVELY WHEN TO STRIKE.

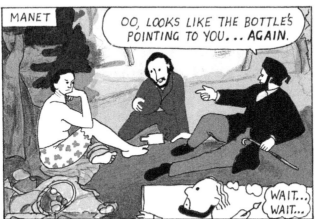

MANET

OO, LOOKS LIKE THE BOTTLE'S POINTING TO YOU... AGAIN.

WAIT... WAIT...

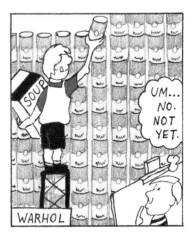

UM... NO. NOT YET.

WARHOL

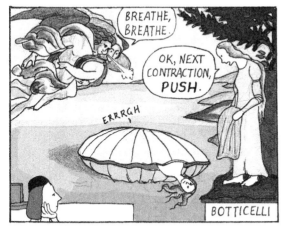

BREATHE, BREATHE.

OK, NEXT CONTRACTION, PUSH.

ERRRGH

BOTTICELLI

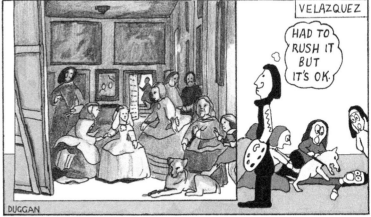

VELAZQUEZ

HAD TO RUSH IT BUT IT'S OK.

DUGGAN

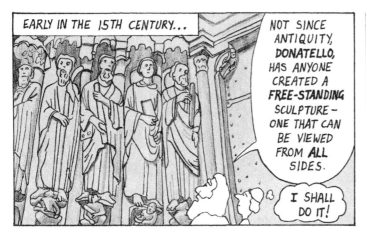

EARLY IN THE 15TH CENTURY...

NOT SINCE ANTIQUITY, **DONATELLO**, HAS ANYONE CREATED A **FREE-STANDING** SCULPTURE — ONE THAT CAN BE VIEWED FROM **ALL** SIDES.

I SHALL DO IT!

HMM... TRY AGAIN.

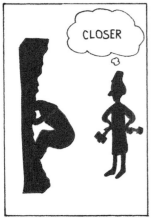

CLOSER

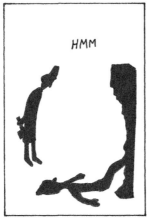

HMM

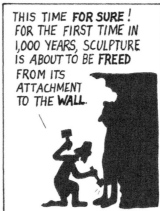

THIS TIME **FOR SURE!** FOR THE FIRST TIME IN 1,000 YEARS, SCULPTURE IS ABOUT TO BE **FREED** FROM ITS ATTACHMENT TO THE **WALL**.

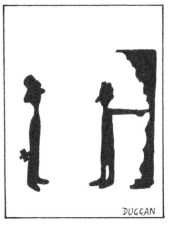

DUGGAN

Not quite right. What Donatello created was the first unsupported standing work of *bronze* since antiquity (which basically means before the Middle Ages). This was his statue of David, which he created in the 1440s. Coincidentally, it was also the first free-standing *male* nude sculpture since then. But the jokey possibilities of carving tempted me to stray from my usual fastidious fidelity to the truth, as exhibited elsewhere in this Untrue History of Art book.

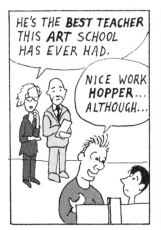

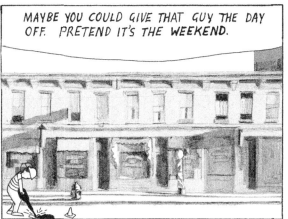

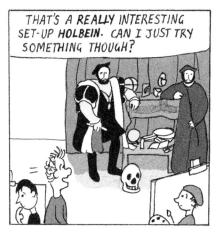

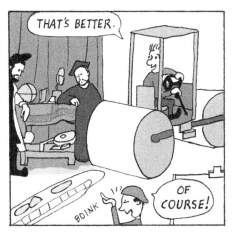

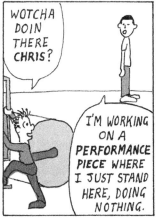

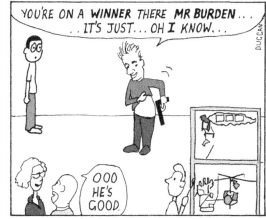

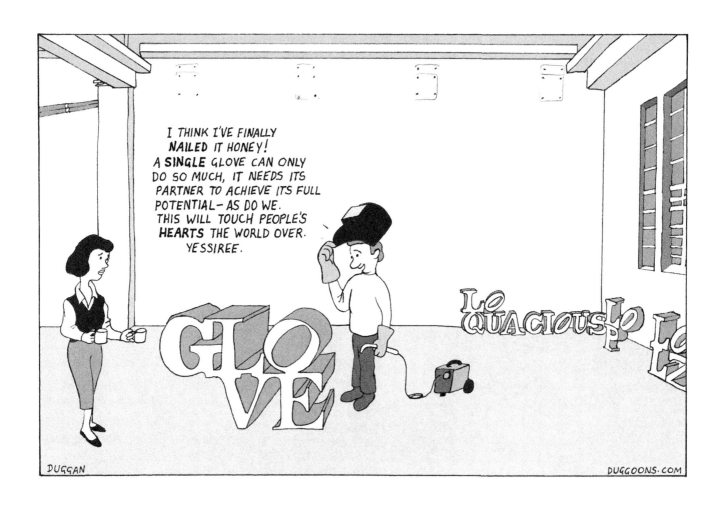

42

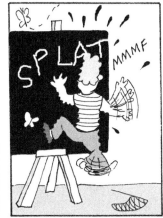
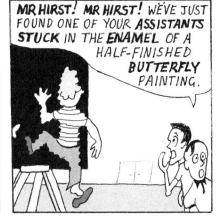

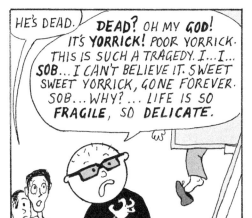
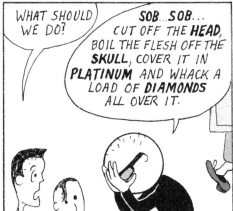
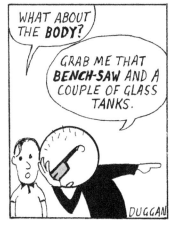

Damien Hirst has made butterfly paintings, a diamond encrusted skull, animals cut in half in tanks, and a ton of other stuff. Unfortunately he can't even give them away.

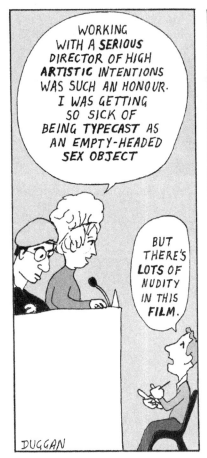

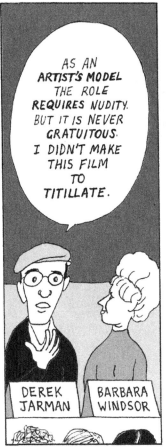

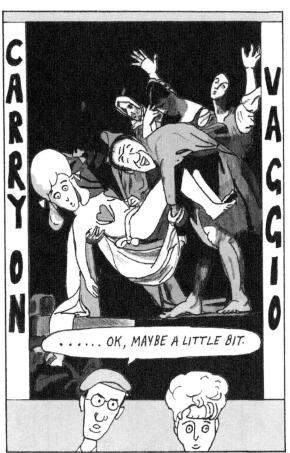

Carry On Vaggio was the darkest comedy of the Carry On series. Yet it was still a lot funnier than Derek Jarman's *Caravaggio*.

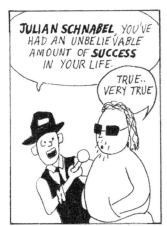

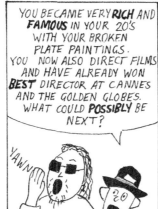

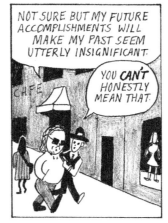

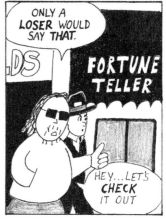

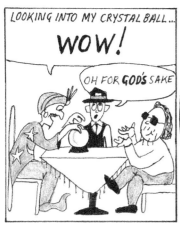

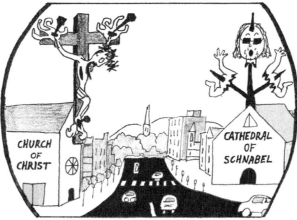

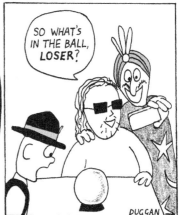

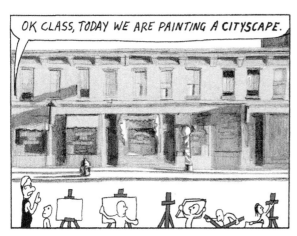

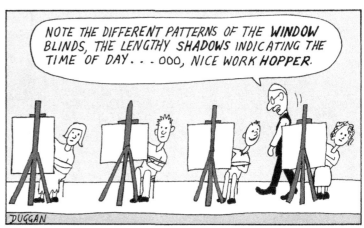

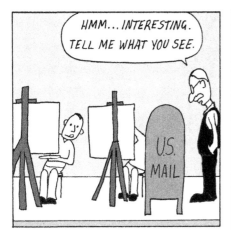

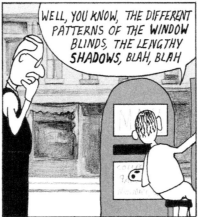

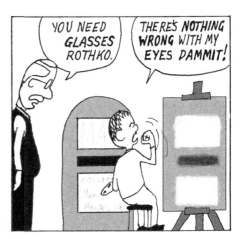

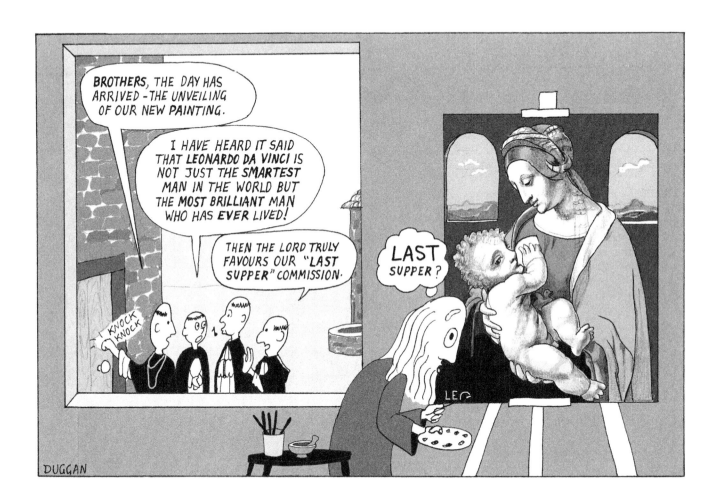

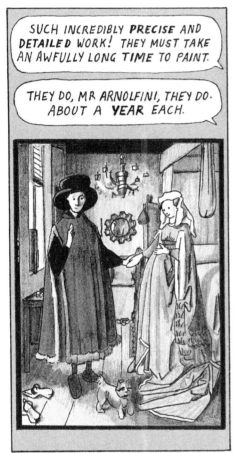

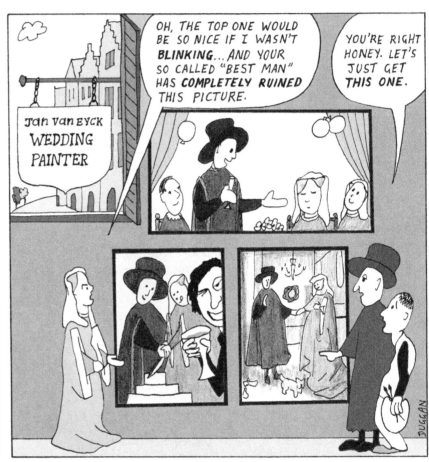

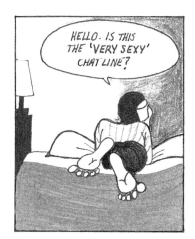
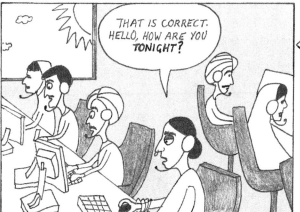
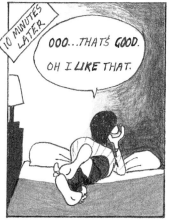
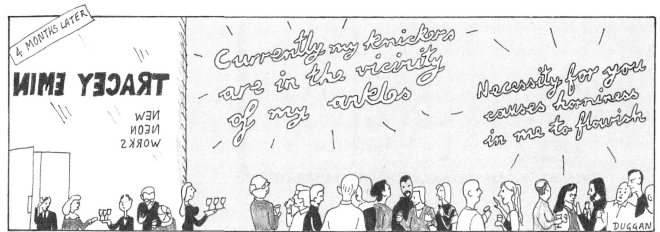

Tracey Emin sometimes makes neon signs of racy phrases in her own handwriting. It is extremely presumptuous to say of course, but I think the above offers a glimmer of insight into the unfathomable mysteries of the creative process.

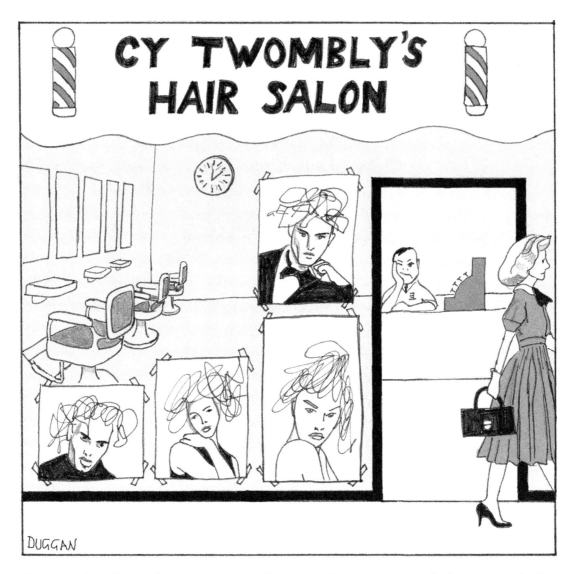

Long before he was acclaimed as one of the world's greatest painters, Cy Twombly was known to many as the world's worst hairdresser.

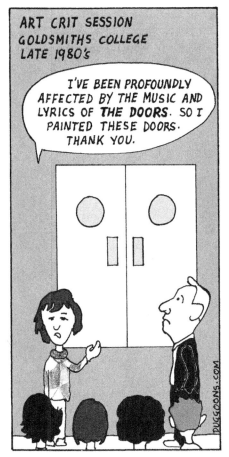

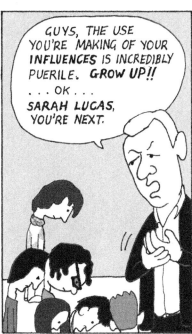

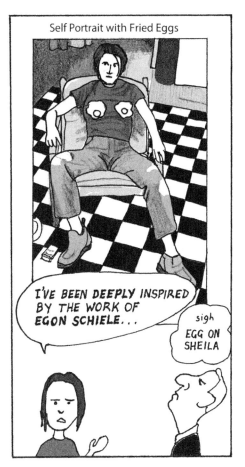

Part of the impetus for the Young British Artist phenomenon of the 1990s (the YBAs) was the teaching of Michael Craig-Martin. He gave many of them the courage of their convictions, like Gary Hume's paintings of doors; Sarah Lucas's forays into feminism and food stuffs; and Damien Hirst's animal welfare work.

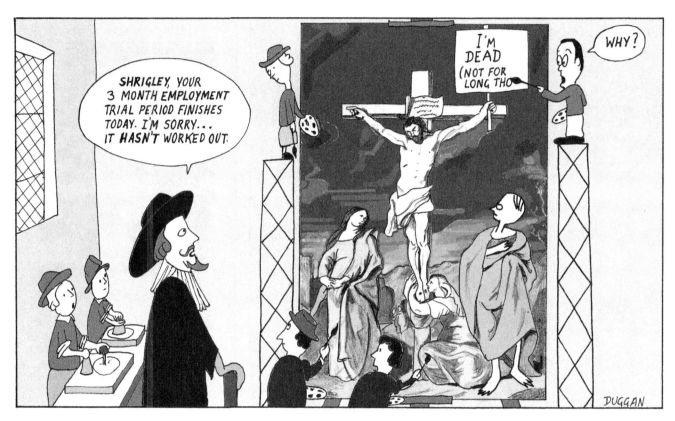

An apprenticeship with an established artist was, for hundreds of years, the only career path available to someone of artistic inclinations.

David Shrigley is a British artist who makes very funny things. Referenced here is a work of his of a stuffed cat holding a sign saying "I'm Dead". He draws terribly, which is also funny.

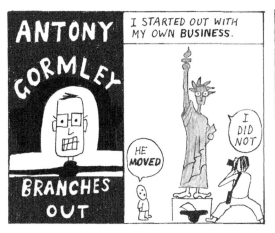

ANTONY GORMLEY BRANCHES OUT

I STARTED OUT WITH MY OWN BUSINESS.

HE MOVED

I DID NOT

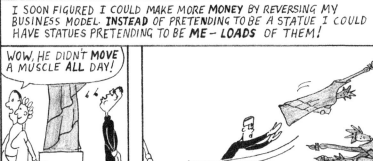

I SOON FIGURED I COULD MAKE MORE **MONEY** BY REVERSING MY BUSINESS MODEL. **INSTEAD** OF PRETENDING TO BE A STATUE I COULD HAVE STATUES PRETENDING TO BE **ME** – **LOADS** OF THEM!

WOW, HE DIDN'T **MOVE** A MUSCLE **ALL** DAY!

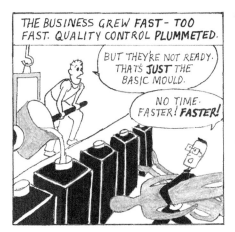

THE BUSINESS GREW **FAST** – TOO FAST. QUALITY CONTROL **PLUMMETED**.

BUT THEY'RE NOT READY. THAT'S **JUST** THE BASIC MOULD.

NO TIME. FASTER! **FASTER!**

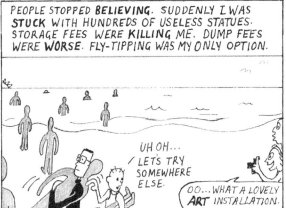

PEOPLE STOPPED **BELIEVING**. SUDDENLY I WAS **STUCK** WITH HUNDREDS OF USELESS STATUES. STORAGE FEES WERE **KILLING** ME. DUMP FEES WERE **WORSE**. FLY-TIPPING WAS MY ONLY OPTION.

UH OH... LET'S TRY SOMEWHERE ELSE.

OO...WHAT A LOVELY **ART** INSTALLATION.

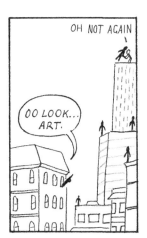

OH NOT AGAIN

OO LOOK... ART.

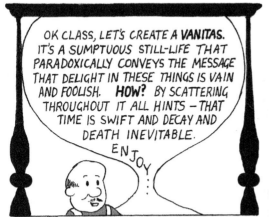

OK CLASS, LET'S CREATE A **VANITAS.** IT'S A SUMPTUOUS STILL-LIFE THAT PARADOXICALLY CONVEYS THE MESSAGE THAT DELIGHT IN THESE THINGS IS VAIN AND FOOLISH. **HOW?** BY SCATTERING THROUGHOUT IT ALL HINTS — THAT TIME IS SWIFT AND DECAY AND DEATH INEVITABLE. ENJOY...

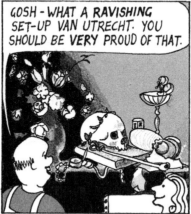

GOSH — WHAT A **RAVISHING** SET-UP VAN UTRECHT. YOU SHOULD BE **VERY** PROUD OF THAT.

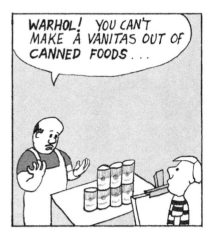

WARHOL! YOU CAN'T MAKE A VANITAS OUT OF **CANNED FOODS...**

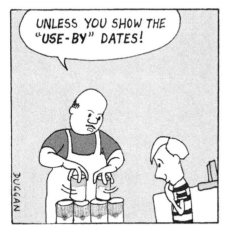

UNLESS YOU SHOW THE **"USE-BY"** DATES!

DUGGAN

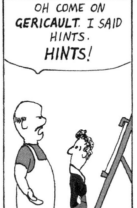

OH COME ON **GERICAULT.** I SAID HINTS. **HINTS!**

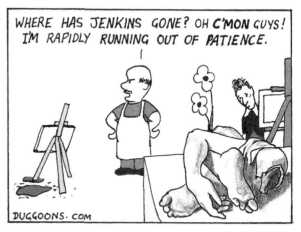

WHERE HAS JENKINS GONE? OH **C'MON** GUYS! I'M RAPIDLY RUNNING OUT OF **PATIENCE.**

DUGGOONS.COM

Masterpiece by Arcimboldo ruined in restoration attempt by amateur art restorer

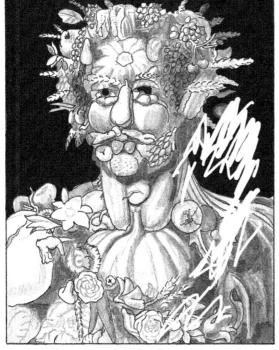

BEFORE

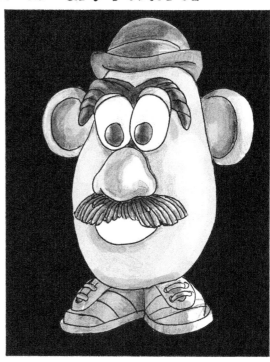

AFTER

In the 16th century Giuseppe Arcimboldo painted faces cleverly made up of foodstuffs and other objects. But to see the greatest transformation in the history of art, go to the internet and look up "the amateur restoration of a painting of Jesus by a little old lady in Spain". Or if you're pressed for time, "Monkey Christ".

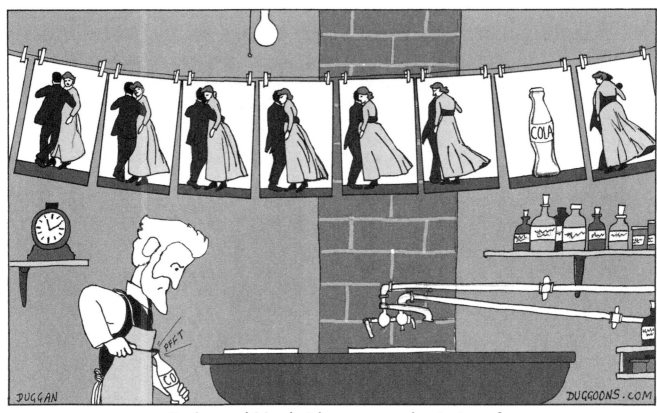

Eadweard Muybridge – an early victim of
subliminal advertising.

In the 1870s Muybridge used multiple cameras to capture motion in stop-action photographs. This was a revelation. It showed things that were too fast for the human eye to perceive, most famously his sequence of a horse galloping. Artists had always depicted this movement with the front and hind legs extended simultaneously. Muybridge showed that this never happens. Consequently, several artists were prosecuted for fraud, receiving lengthy jail sentences. I think one was executed.

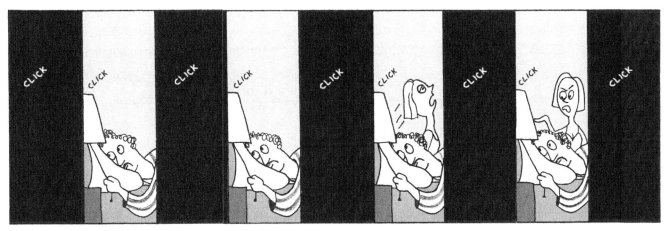

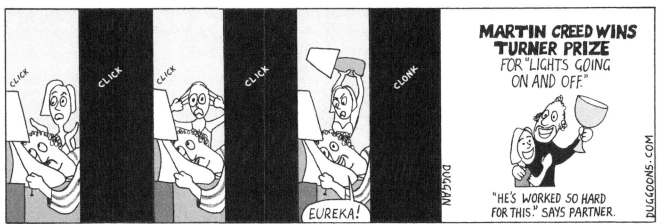

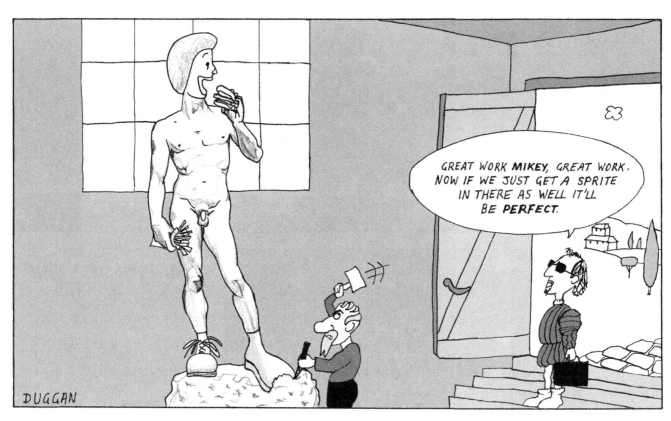

The rise of capitalism marked a change of patronage
for artists.

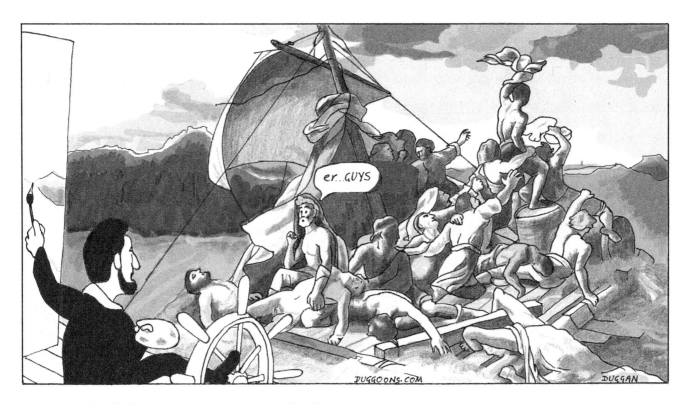

With his painting *The Raft of Medusa*, Theodore Gericault went to extraordinary lengths to capture that desperate moment of hope when the survivors spotted a ship in the distance.

I was quite sure this cartoon would be funnier from a front-on viewpoint, but it was tricky to draw and unfortunately, as I really should have realised, it no longer looked like the painting.

...AND 10 MORE DIAMOND CABINETS FOR... ✿@#! IS IT PRONOUNCED **SHEEK** OR **SHAKE**? TELL SHEIKH WHAT'S-HIS-FACE IF HE DOESN'T SORT IT OUT BY TOMORROW THE DEAL'S **OFF!**

DAMIEN HIRST INC.

SIGH... I WAS NEVER THIS GRUMPY WHEN I WAS A STUDENT.

THE "BUSINESS" HAS TAKEN OVER... **THAT'S IT!** TIME TO STRIP IT ALL BACK, BECOME AN ARTIST AGAIN. I'M GOING TO PAINT PICTURES — **BY MYSELF!**

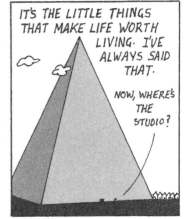

IT'S THE LITTLE THINGS THAT MAKE LIFE WORTH LIVING. I'VE ALWAYS SAID THAT.

NOW, WHERE'S THE STUDIO?

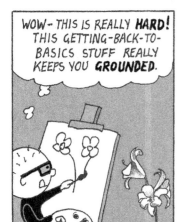

WOW— THIS IS REALLY **HARD!** THIS GETTING-BACK-TO-BASICS STUFF REALLY KEEPS YOU **GROUNDED.**

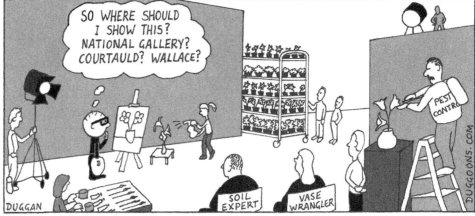

SO WHERE SHOULD I SHOW THIS? NATIONAL GALLERY? COURTAULD? WALLACE?

DUGGAN

SOIL EXPERT

VASE WRANGLER

PEST CONTROL

DUGGOONS.COM

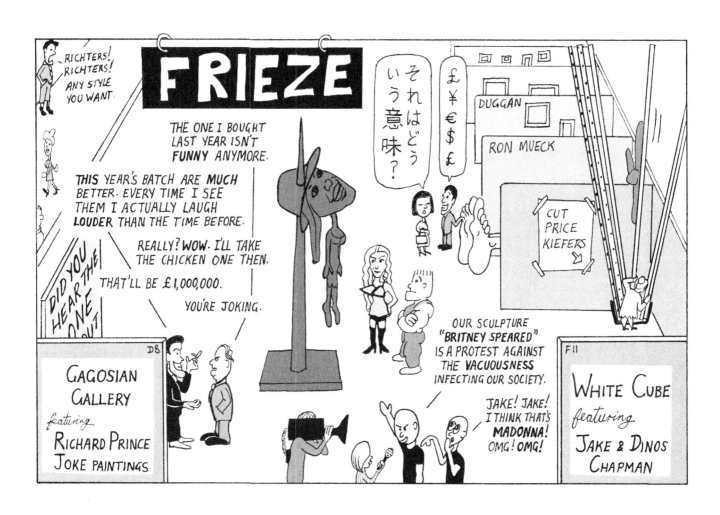

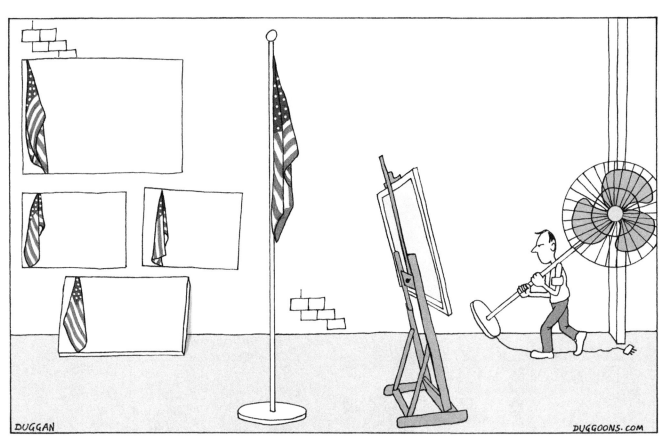

Jasper makes a breakthrough

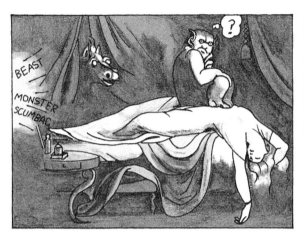

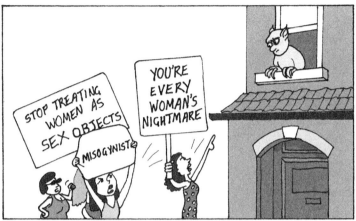

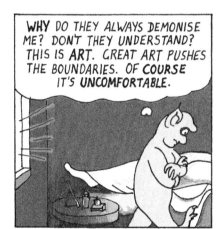

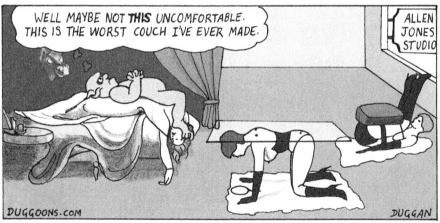

When Henri Fuseli first exhibited his painting *The Nightmare* in 1782 it was one of those very rare occasions in art history of an overnight sensation. Allen Jones had another when he showed *Table* in 1970. He was accused of objectifying women – simply because he made objects out of women!

ANDREW **WARHOLA** CHANGED HIS NAME TO **ANDY WARHOL** WHEN HE EMIGRATED TO **AMERICA** FROM THE **PLANET VULCAN**

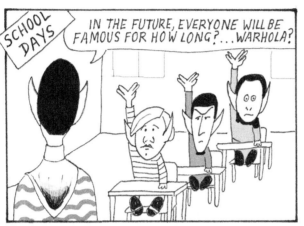

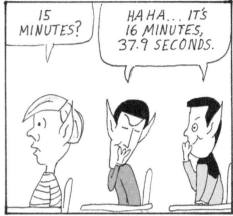

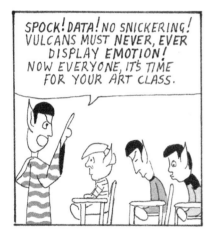

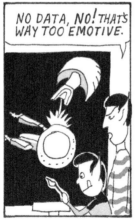

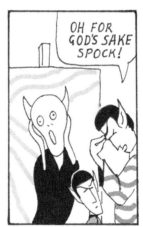

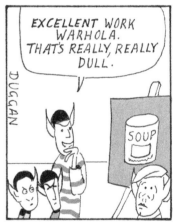

Andy Warhol's public persona was a blank; devoid of personality. Ergo a Vulcan – obviously. And yes, I know Data wasn't a Vulcan. Actually, neither was Warhol. This is called artistic license.

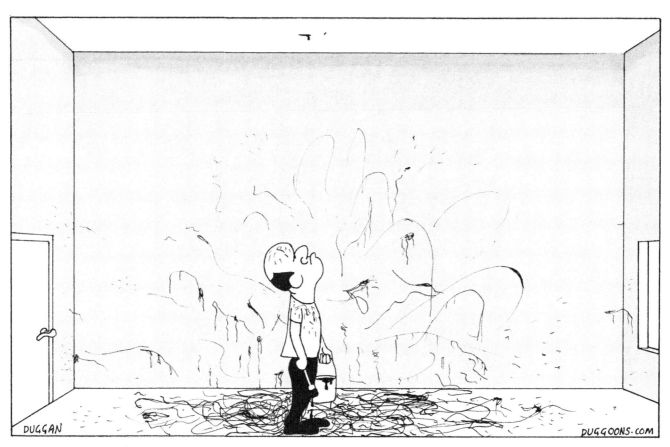

Jackson Pollock's first ceiling commission was also his last.

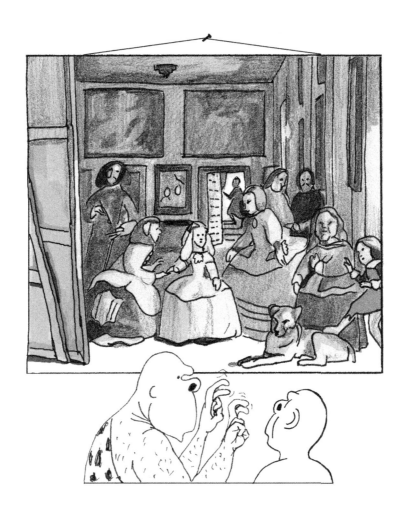

CRITICS

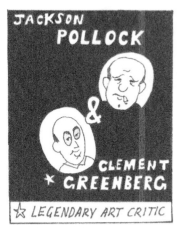

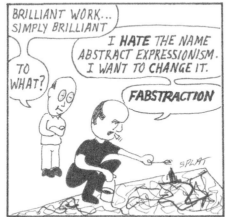

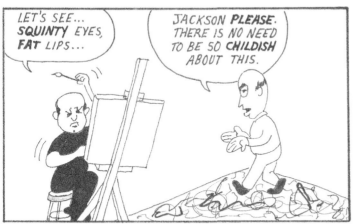

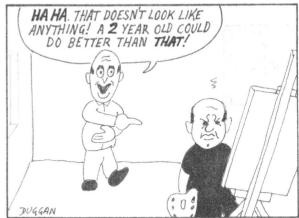

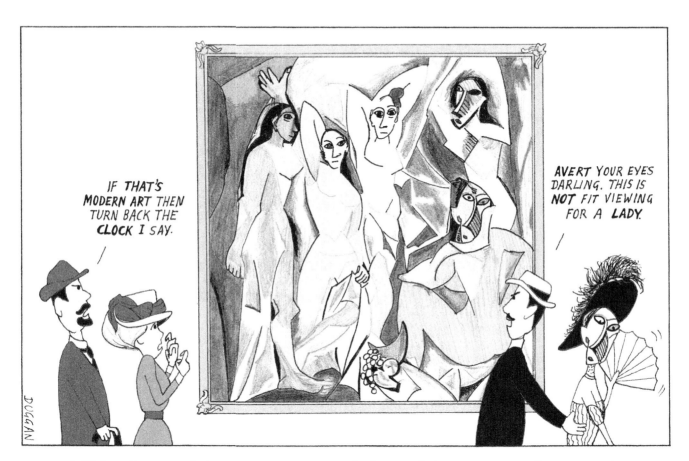

Mildred's scandalous past as an artist's model was never discovered.

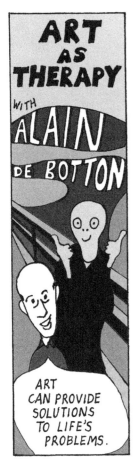

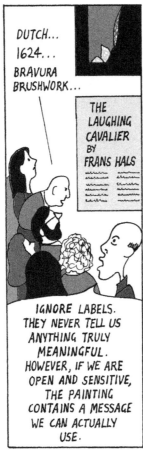

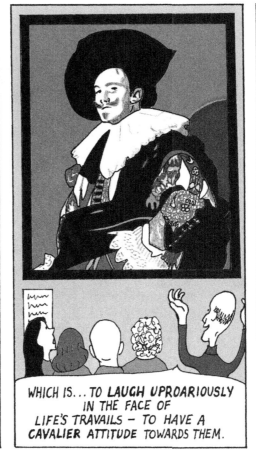

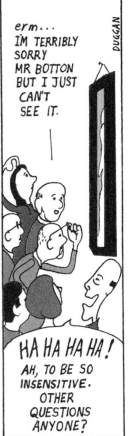

It's a mystery how some paintings get their titles. He's not even smiling. It's as silly as calling *Arrangement in Grey and Black No.1* "Whistler's Mother".

OH WOW

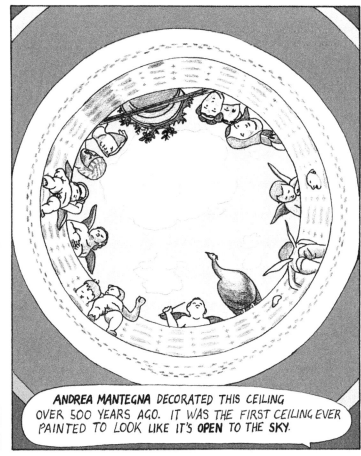

ANDREA MANTEGNA DECORATED THIS CEILING OVER 500 YEARS AGO. IT WAS THE FIRST CEILING EVER PAINTED TO LOOK LIKE IT'S **OPEN** TO THE SKY.

IT'S INCREDIBLY EFFECTIVE.

DUGGAN DUGGOONS.COM

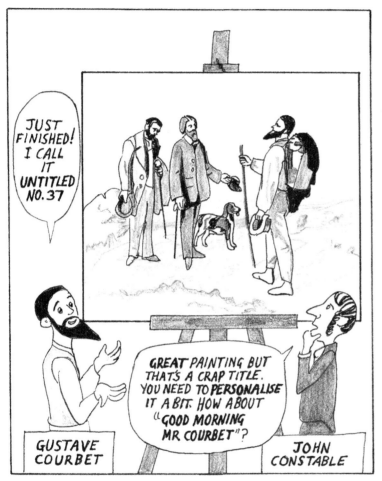

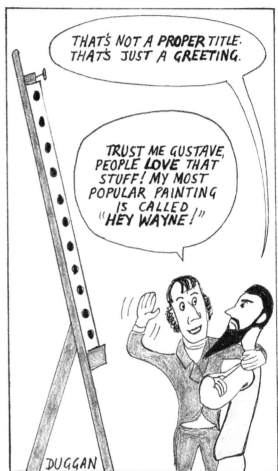

If you don't speak French, Gustave Courbet's "Bonjour, Monsieur Courbet" translates as "Good Morning, Mr Courbet". Je vous en prie. I actually have a rule where if I depict two artists interacting, they have to have lived at the same time, or at least overlapping times, to make it slightly believable. Strange.

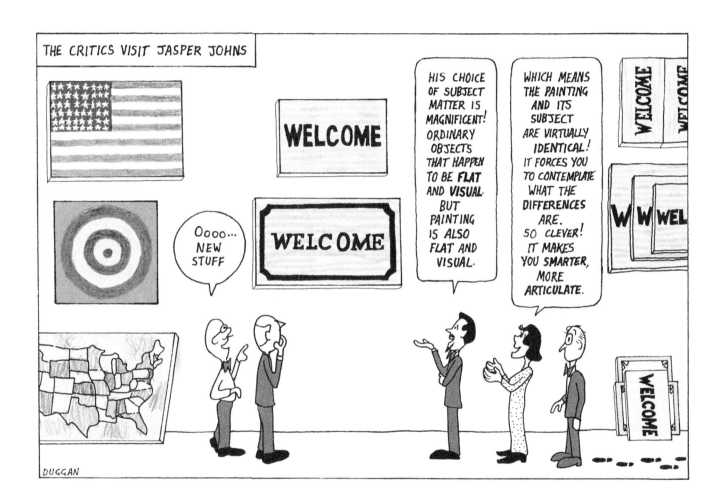

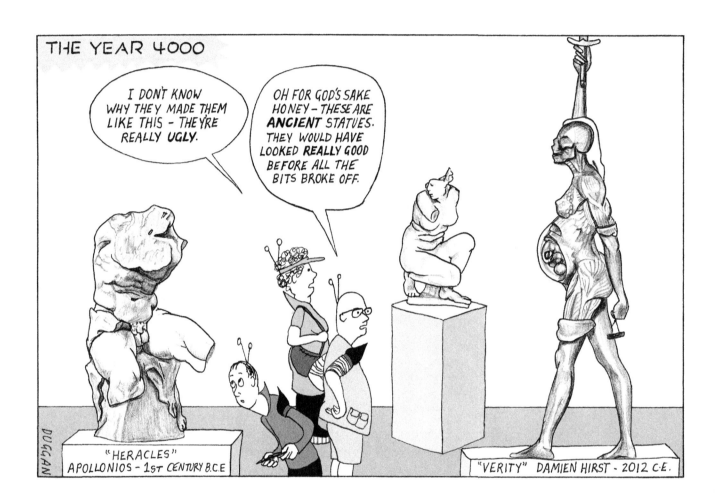

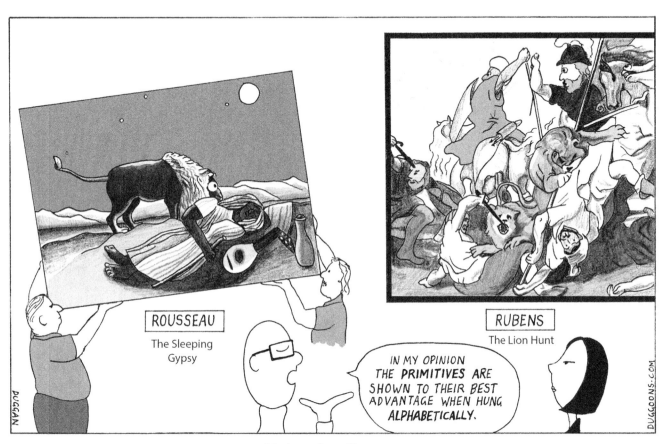

Naive Art Curator

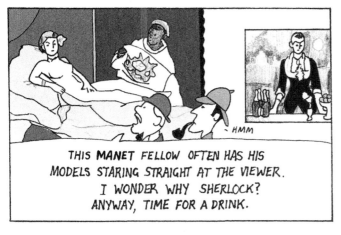

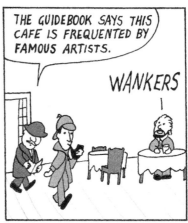

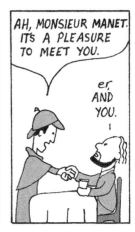

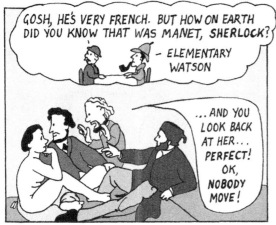

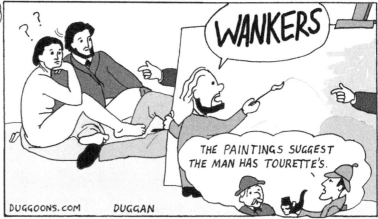

Why do the subjects of Manet's paintings so often stare straight out at the viewer? I sent Sherlock Holmes to find out.

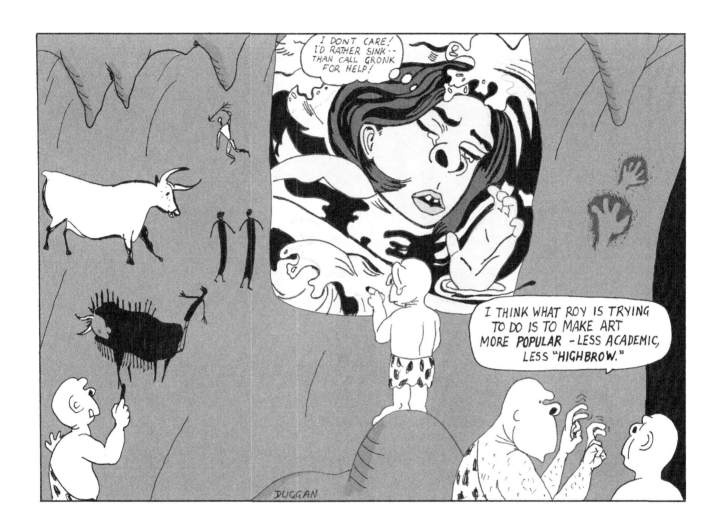

Once, whilst strolling through the Prado watching Ren and Stimpy on my iphone, I began to ponder the difference between high and low art. But just then I caught sight of *Las Meninas*. It broke my concentration, so I still have no idea.

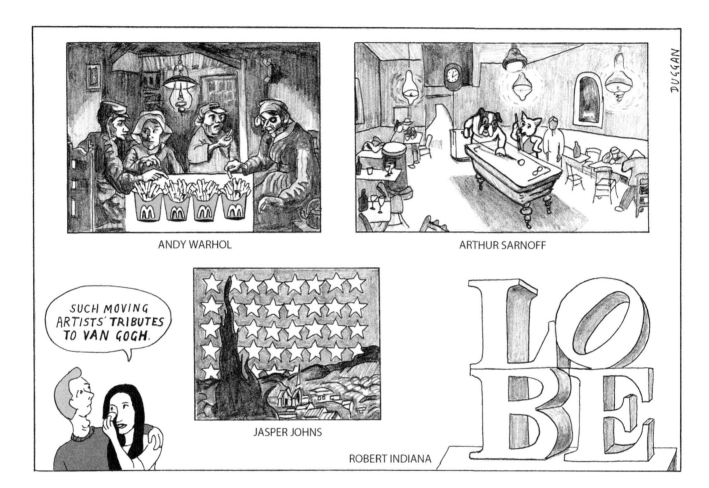

ANDY WARHOL

ARTHUR SARNOFF

JASPER JOHNS

ROBERT INDIANA

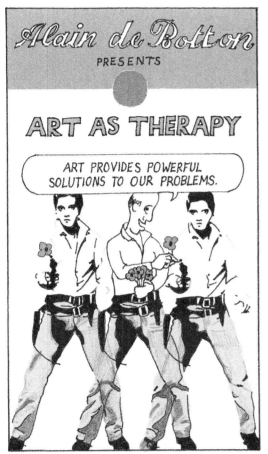

SOME PEOPLE VIEW **POP ART** AS JUST **CRASS** POPULAR CULTURE PARADING AS HIGH ART. IN FACT, IT IS FULL OF PENETRATING INSIGHTS INTO EVERY ASPECT OF OUR LIVES.

DUGGOONS.COM

ROY LICHTENSTEIN IS PARTICULARLY **ASTUTE** ON MATTERS OF THE **HEART**. HERE HE TELLS US: "IF YOU WANT A RELATIONSHIP TO WORK, DON'T BLOW THE BUTT TRUMPET."

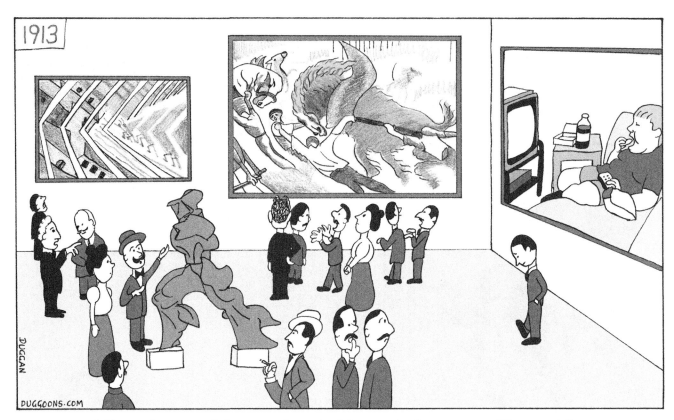

Misunderstood, ignored and ultimately forgotten. The sad fate
of Futurism's most visionary artist.

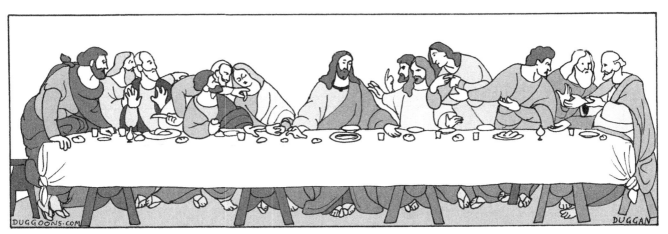

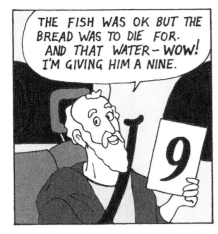

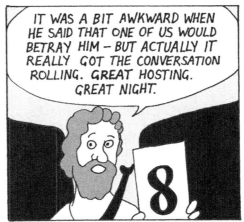

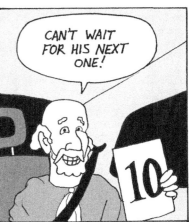

There is a British TV show called Come Dine With Me where normal people have a meal at each others houses, then rate it in the car on the way home. How the Apostles managed to hail Ubers before the invention of phones is nothing short of a miracle

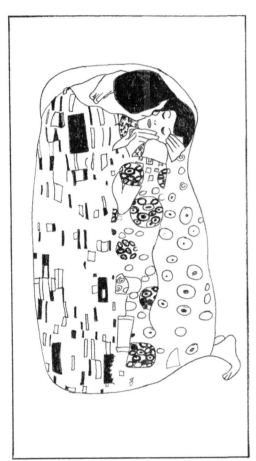

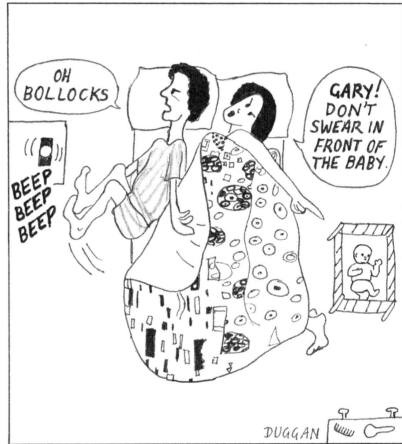

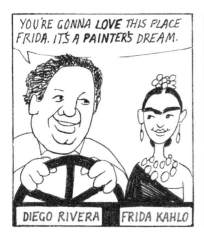
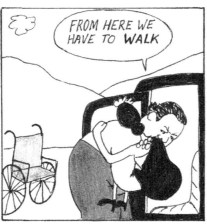
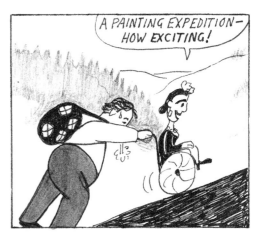
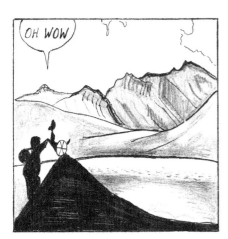
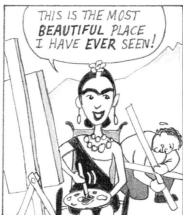
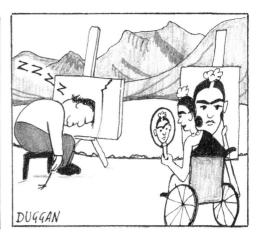

Frida Kahlo painted lots of self portraits. Diego Rivera ate a lot. They were married.

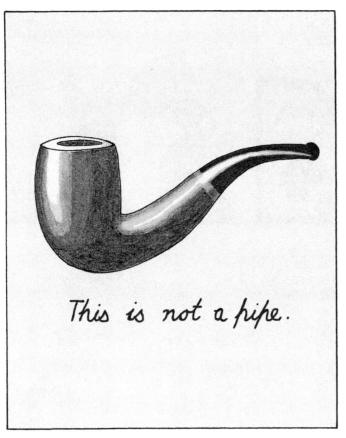

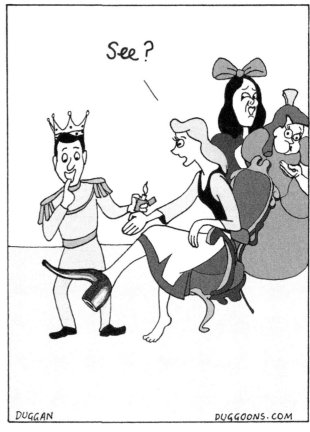

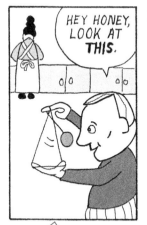

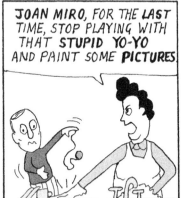

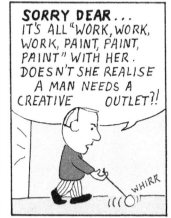

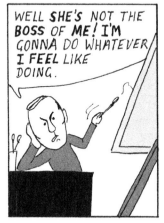

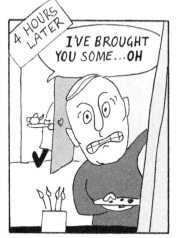

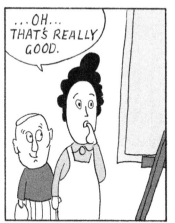

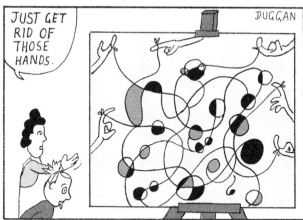

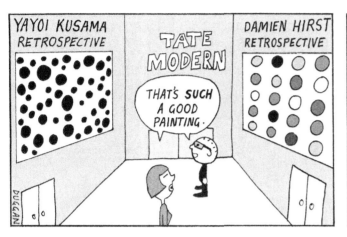
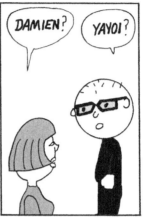
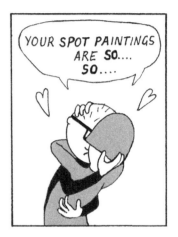
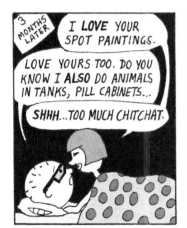
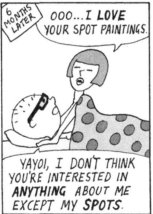
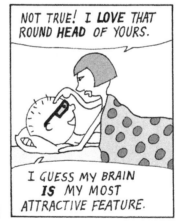
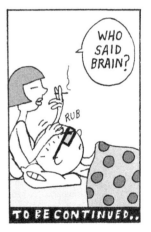

Yayoi Kusama is famous for her spot paintings. Damien Hirst has done a few too.

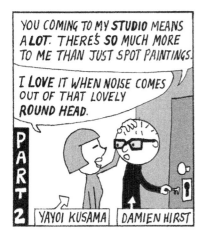

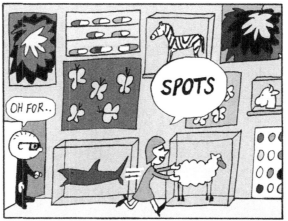

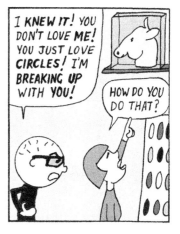

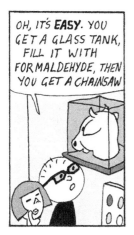

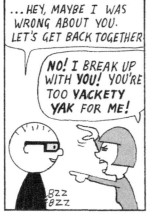

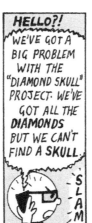

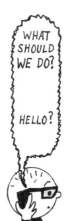

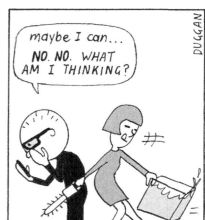

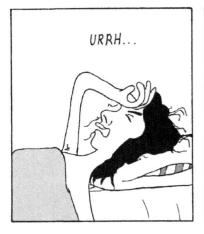
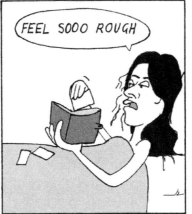
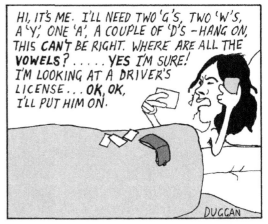
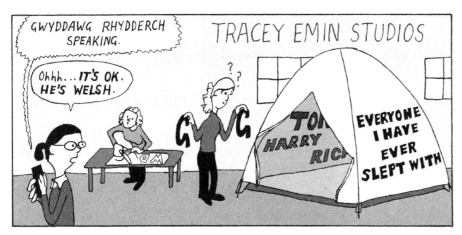
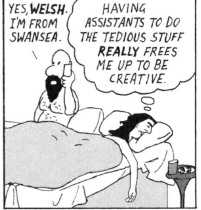

Everyone I Have Ever Slept With 1963–1995 was a tent upon which Emin embroidered the names of everyone she had ever slept with. It was destroyed in a fire in 2004, which means the cartoon above is the world's only memorial of this particular union.

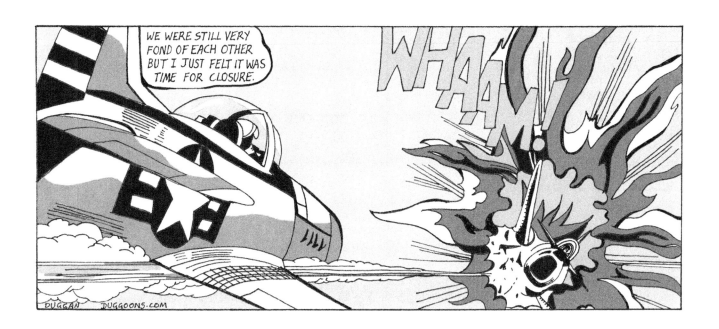

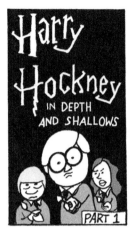

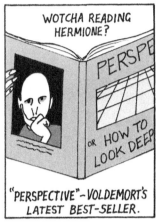

WOTCHA READING HERMIONE?

"PERSPECTIVE" — VOLDEMORT'S LATEST BEST-SELLER.

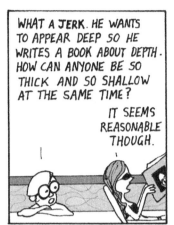

WHAT A **JERK**. HE WANTS TO APPEAR DEEP SO HE WRITES A BOOK ABOUT DEPTH. HOW CAN ANYONE BE SO THICK AND SO SHALLOW AT THE SAME TIME?

IT SEEMS REASONABLE THOUGH.

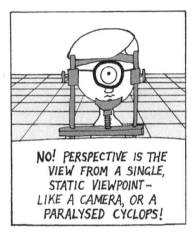

NO! PERSPECTIVE IS THE VIEW FROM A SINGLE, STATIC VIEWPOINT — LIKE A CAMERA, OR A PARALYSED CYCLOPS!

WE GET A **REAL** SENSE OF SPACE BY LOOKING **THIS** WAY AND **THAT**. IT'S MORE LIKE **LOTS** OF PHOTOS.

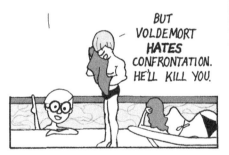

... LOTS OF PHOTOS... **THAT'S IT!** I'LL MAKE AN ARTWORK THAT PROVES MY POINT AND CONFRONT VOLDEMORT WITH IT.

BUT VOLDEMORT **HATES** CONFRONTATION. HE'LL KILL YOU.

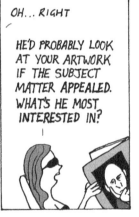

OH... RIGHT

HE'D PROBABLY LOOK AT YOUR ARTWORK IF THE SUBJECT MATTER APPEALED. WHAT'S HE MOST INTERESTED IN?

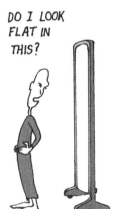

DO I LOOK FLAT IN THIS?

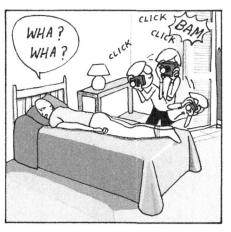

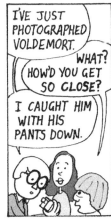

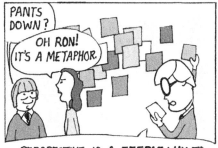

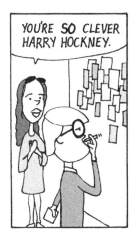

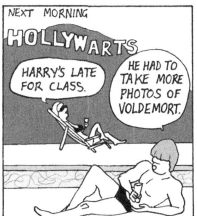

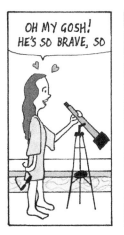

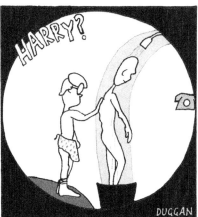

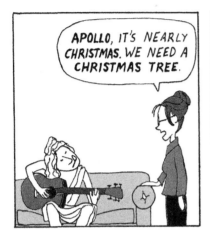

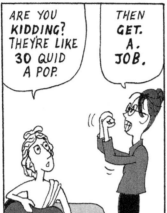

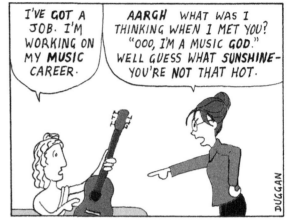

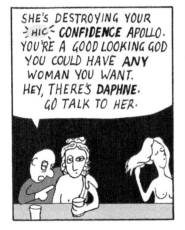

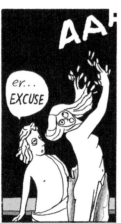

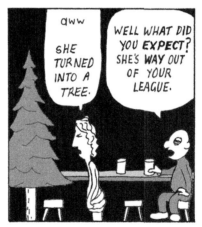

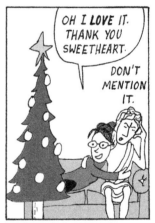

Apollo was the Greek god of both music and the sun. One day he got the hots for the nymph Daphne, so, playing it cool and casual, he started chasing her. She yelled for help to her river god father, who, thinking quickly, resolved the situation by turning her into a tree (thanks Dad). Bernini's interpretation of this transformation is an astonishing marvel of the art of sculpture – as you can no doubt tell from this cartoon.

THEIR EYES MET. INSTANTLY THEY WERE BOTH OVERWHELMED BY A FEELING OF PROFOUND **CONNECTION.** HERE WAS SOMEONE WHO **KNEW** WHAT IT FELT LIKE TO BE DIFFERENT. WITH A TREMBLING THRILL, THESE TWO **LONELY SURREALISTS** SUDDENLY UNDERSTOOD THAT THEIR DAYS OF LONELINESS WERE OVER.

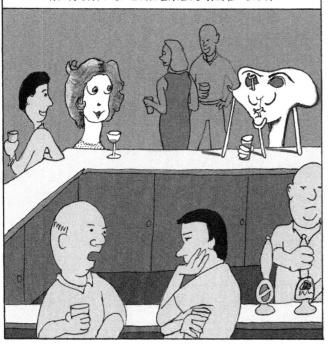

IT DIDN'T WORK OUT THOUGH.

IT'S JUST BEEN A LONG DAY THAT'S ALL.

SOB

ALWAYS A REASON

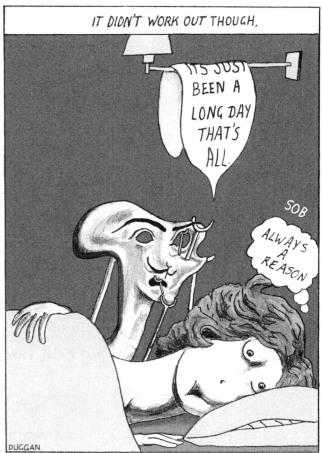

DUGGAN

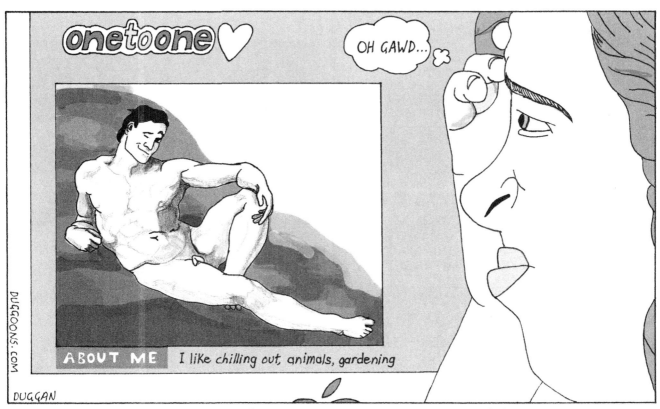

The discouraging lack of options on the dating site left her no choice;
Eve clicked 'like'.

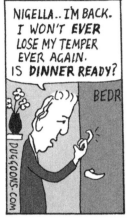
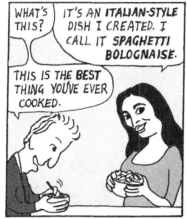
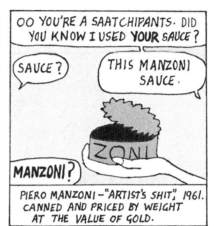
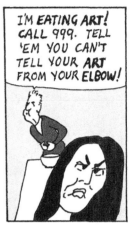

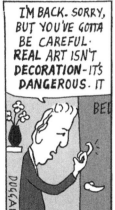

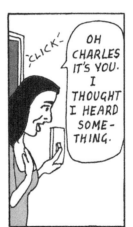
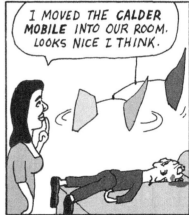

Until they divorced, Charles Saatchi and Nigella Lawson were a famous British power couple; he an art collector and advertising mogul, she a foodie goddess, i.e. TV cook. After a very public falling out, Charles is shown coming back twice, first from the police station, and later from a hospital (I made the second one up). This is what it's like in the high life. Luckily I'm a low life so my existence is blissfully tranquil.

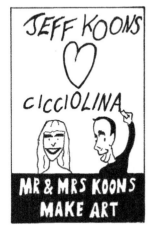

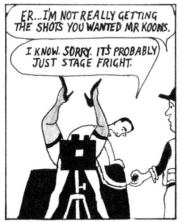

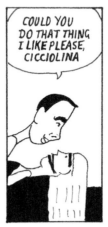

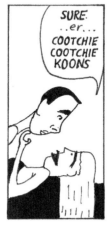

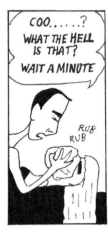

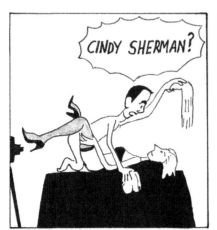

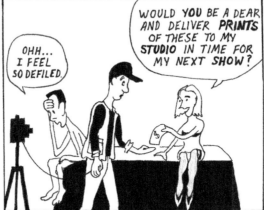

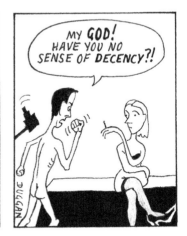

Jeff Koons' first marriage was to the Hungarian-born Italian porn star Cicciolina (Ilona Staller). There were suspicions that their marriage was unconsummated but this was disproved by his series of billboard-sized photographs of the couple making a lot of love. Cindy Sherman has made a career of photographing herself dressed up as other people. The perfect stalker.

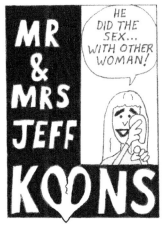

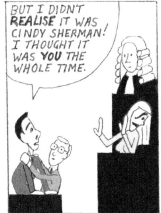

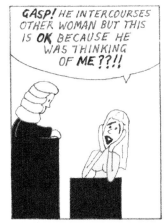

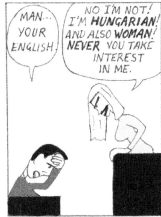

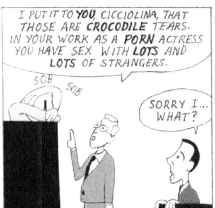

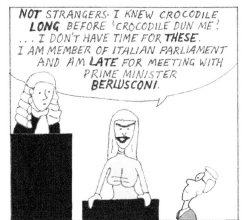

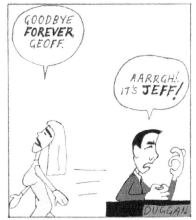

The divorce. Cicciolina was indeed an Italian MP for a five year term. She famously offered to have sex with Saddam Hussein if he gave up his weapons of mass destruction but he didn't have any.

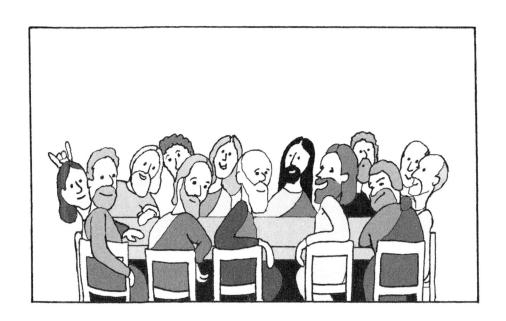

RELIGION

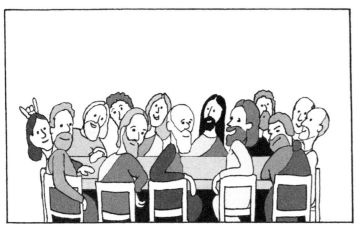
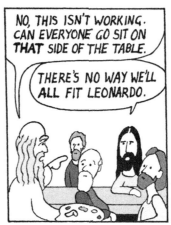
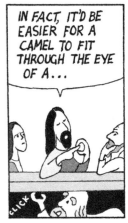
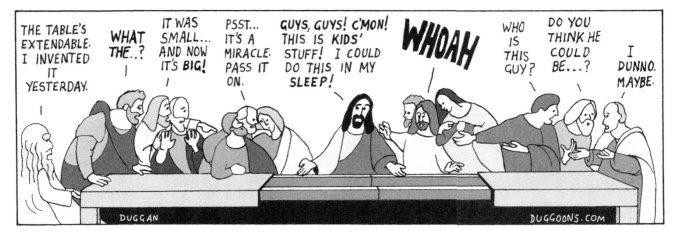

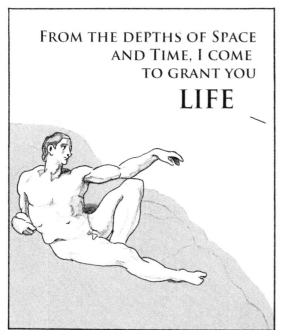 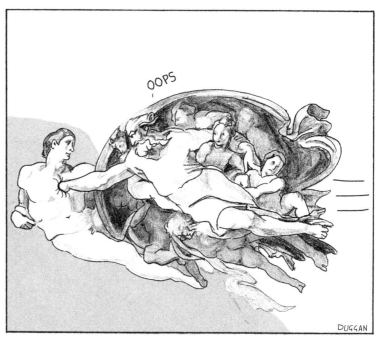

Having lived for eons without matter, without points of reference
of any kind, God found it tricky to gauge his speed.
(After his subsequent successful attempt with Adam,
God forbade any mention of Keith.)

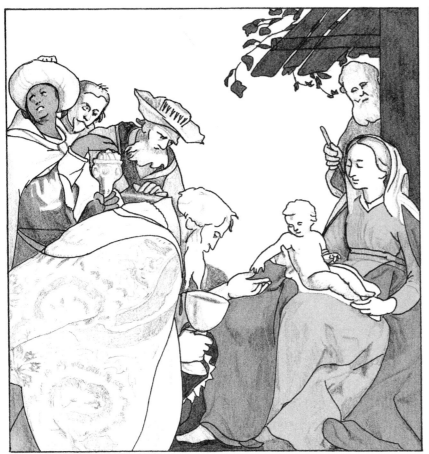

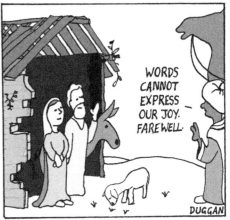

WORDS CANNOT EXPRESS OUR JOY. FAREWELL.

DUGGAN

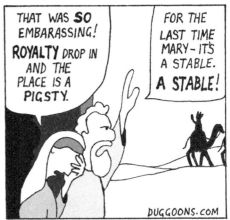

THAT WAS **SO** EMBARASSING! **ROYALTY** DROP IN AND THE PLACE IS A **PIGSTY.**

FOR THE LAST TIME MARY - IT'S A STABLE. **A STABLE!**

DUGGOONS.COM

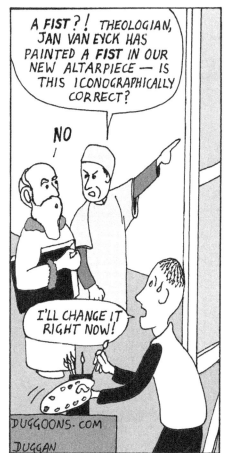

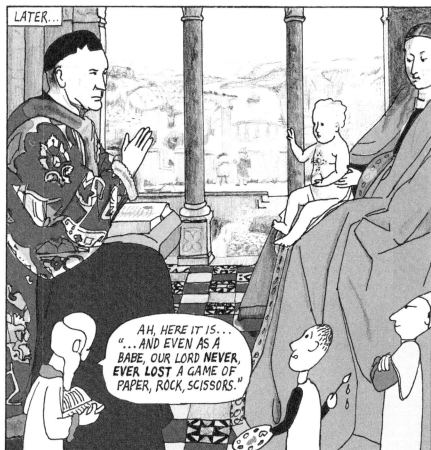

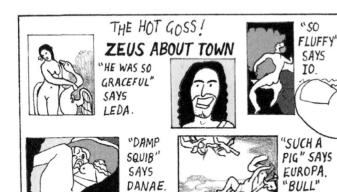

THE HOT GOSS!
ZEUS ABOUT TOWN

"HE WAS SO GRACEFUL" SAYS LEDA.

"SO FLUFFY" SAYS IO.

"DAMP SQUIB" SAYS DANAE.

"SUCH A PIG" SAYS EUROPA. "BULL" SAYS ZEUS.

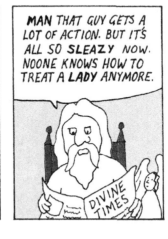

MAN THAT GUY GETS A LOT OF ACTION. BUT IT'S ALL SO SLEAZY NOW. NOONE KNOWS HOW TO TREAT A LADY ANYMORE.

DIVINE TIMES

ANGEL OF THE NORTH, I'D LIKE YOU TO GO TO THAT SWEET GIRL MARY I KEEP TALKING ABOUT AND ANNOUNCE MY INTENTIONS.

YOU'RE A TRUE GENT LORD.

MARY...HELLO?...HELLOO?.. OH WHY DO THEY MAKE THESE ARCHWAYS SO SKINNY?... MARY! GOD WOULD LIKE TO

DUM DE DUM

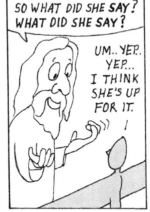

SO WHAT DID SHE SAY? WHAT DID SHE SAY?

UM.. YEP. YEP... I THINK SHE'S UP FOR IT.

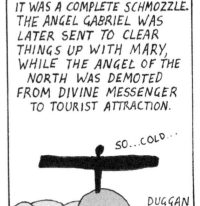

IT WAS A COMPLETE SCHMOZZLE. THE ANGEL GABRIEL WAS LATER SENT TO CLEAR THINGS UP WITH MARY, WHILE THE ANGEL OF THE NORTH WAS DEMOTED FROM DIVINE MESSENGER TO TOURIST ATTRACTION.

SO...COLD...

DUGGAN

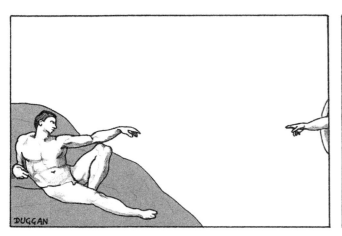

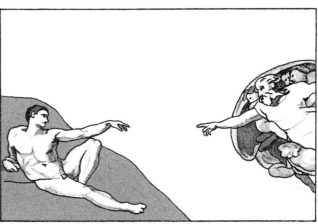

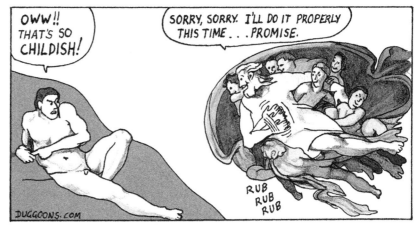

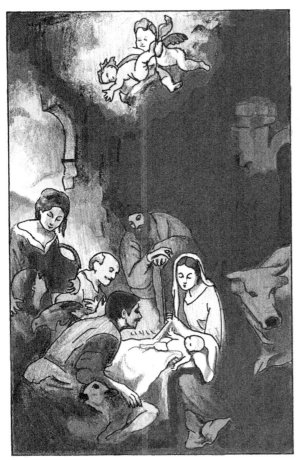

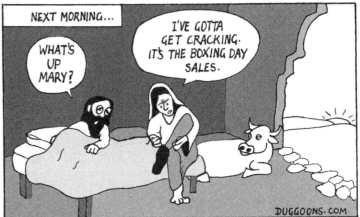

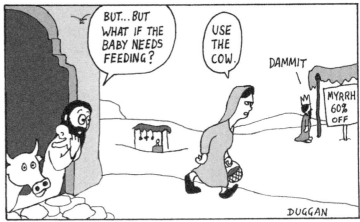

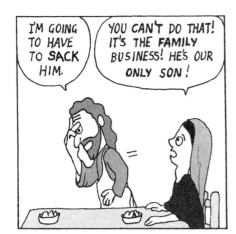
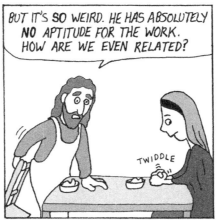
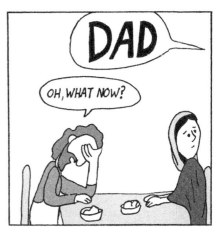
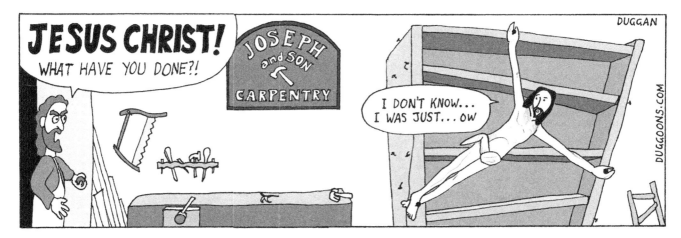

The artwork referenced here is Paul Gauguin's *Yellow Christ*, which has just the right amount of cartoonishness to fit seamlessly into this artoon.

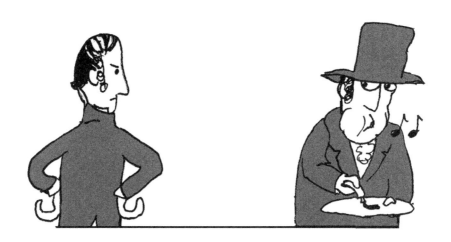

FRIENDS/ COMPETITORS

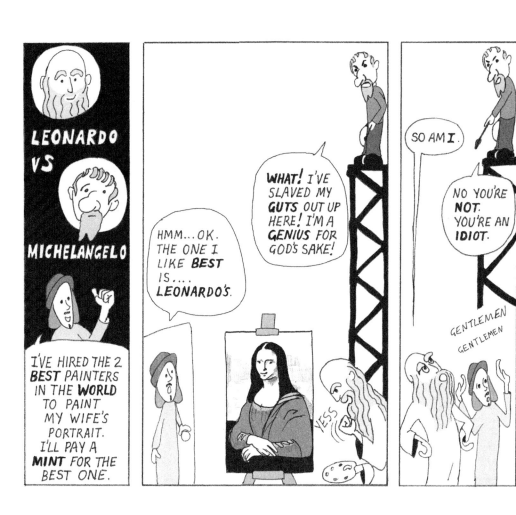
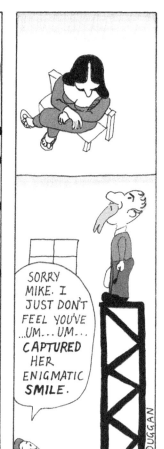

What would you do if you were head of Florence and you happened to have, among your citizenry, two artists who were legends in their own lifetime? Commission them for a painting competition of course, painting the exact same wall (in the Palazzo Vecchio). Brilliant! Unfortunately neither finished their work, but their cartoons (the full-scale preparatory drawings) were, by all contemporary accounts, completely stunning but not very funny.

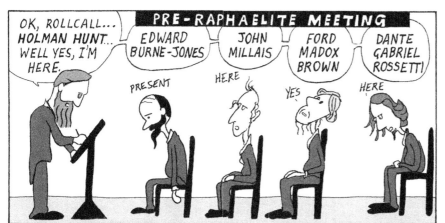

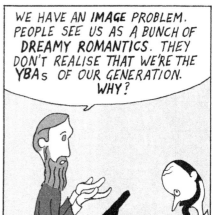

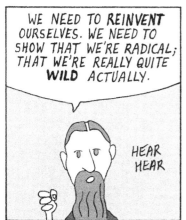

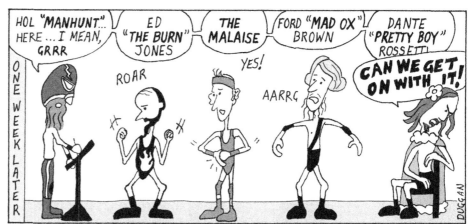

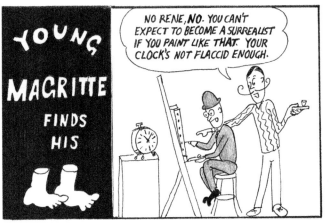

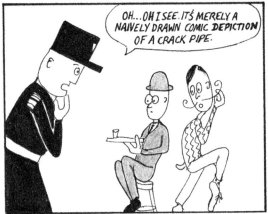

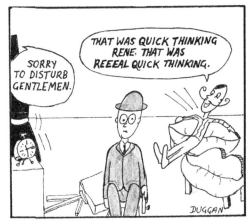

114

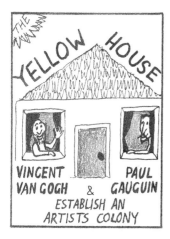

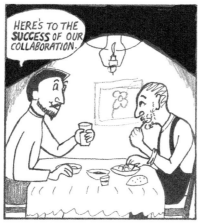

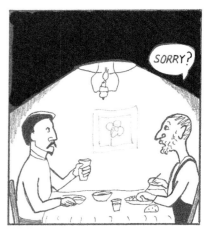

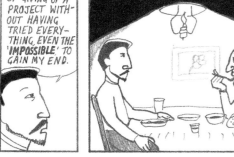

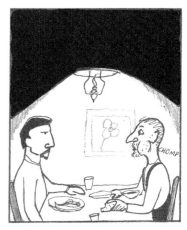

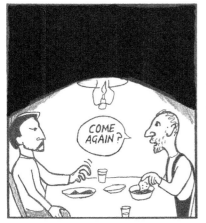

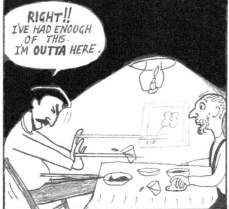

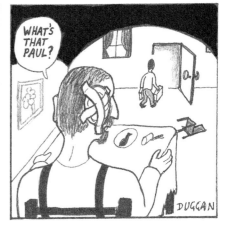

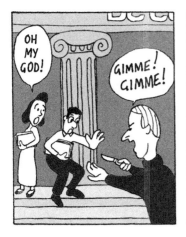
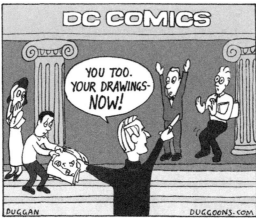
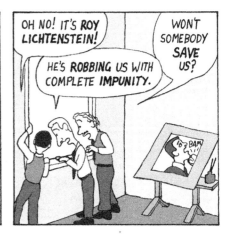
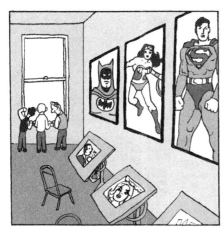
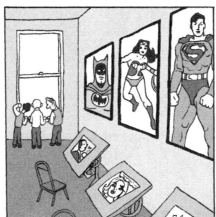
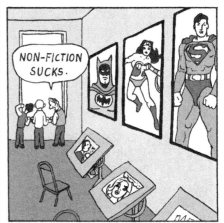

Lots of Roy Lichtenstein's images were based on panels from DC comics. Not sure what to think about that. I like 'em though.

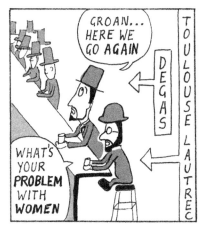
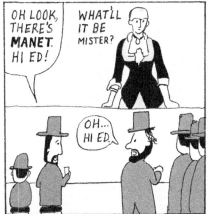
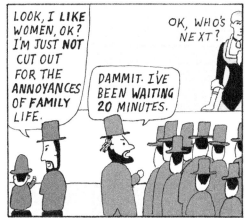
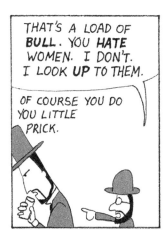
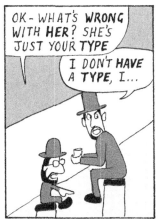
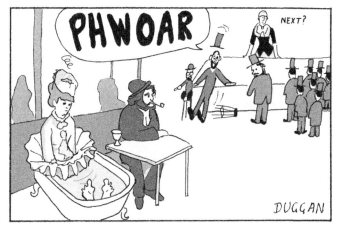

There were suspicions Degas was a misogynist, but that's a lot of time painting and drawing subject matter you apparently dislike. You know, all those things that women do - like washing themselves, drinking absinthe, and dancing in tutus. I have no idea if Edgar Degas and Henri de Toulouse-Lautrec ever even met, much less hung out, but they tickle me as a double act.

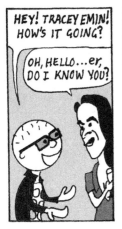

HEY! TRACEY EMIN! HOW'S IT GOING?

OH, HELLO...er, DO I KNOW YOU?

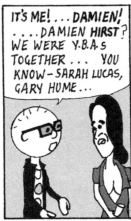

IT'S ME! ... *DAMIEN!* DAMIEN *HIRST?* WE WERE Y.B.A.s TOGETHER ... YOU KNOW — SARAH LUCAS, GARY HUME...

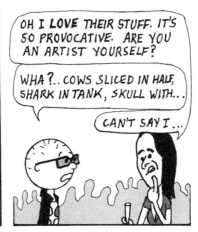

OH I *LOVE* THEIR STUFF. IT'S SO PROVOCATIVE. ARE YOU AN ARTIST YOURSELF?

WHA?.. COWS SLICED IN HALF, SHARK IN TANK, SKULL WITH...

CAN'T SAY I ...

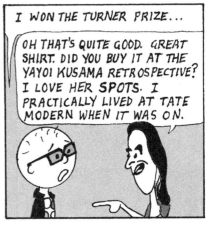

I WON THE TURNER PRIZE...

OH THAT'S QUITE GOOD. GREAT SHIRT. DID YOU BUY IT AT THE YAYOI KUSAMA RETROSPECTIVE? I LOVE HER *SPOTS.* I PRACTICALLY LIVED AT TATE MODERN WHEN IT WAS ON.

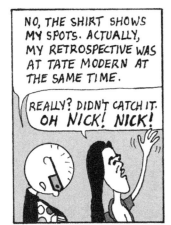

NO, THE SHIRT SHOWS MY SPOTS. ACTUALLY, MY RETROSPECTIVE WAS AT TATE MODERN AT THE SAME TIME.

REALLY? DIDN'T CATCH IT. OH NICK! NICK!

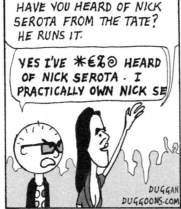

HAVE YOU HEARD OF NICK SEROTA FROM THE TATE? HE RUNS IT.

YES I'VE ✳€%☺ HEARD OF NICK SEROTA · I PRACTICALLY OWN NICK SE

DUGGAN
DUGGOONS.COM

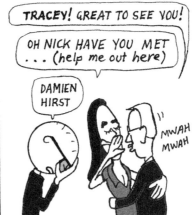

TRACEY! GREAT TO SEE YOU!

OH NICK HAVE YOU MET ... (help me out here)

DAMIEN HIRST

MWAH MWAH

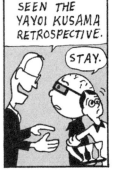

CAN'T SAY I HAVE. ...OH, I SEE YOU'VE SEEN THE YAYOI KUSAMA RETROSPECTIVE.

STAY.

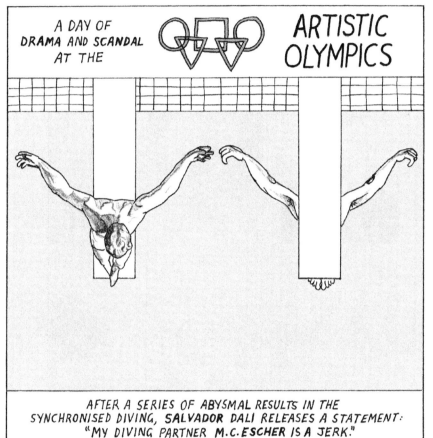

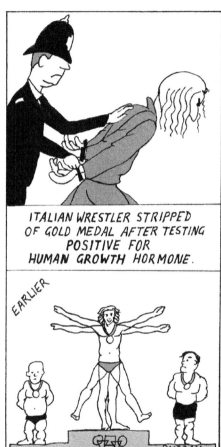

HIGH SCHOOL YEARBOOK *ART CLASS*

Edvard Munch
Alberto Giacometti
Cindy Sherman
Vincent Van Gogh

Dante Gabriel Rossetti
Albrecht Durer
Piet Mondrian
Caspar David Friedrich

DUGGAN

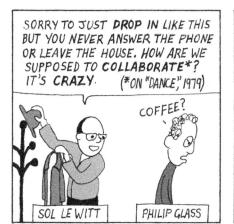
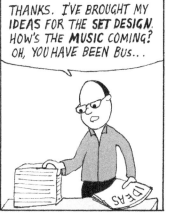
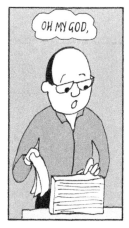
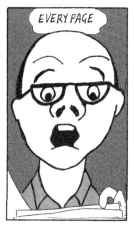
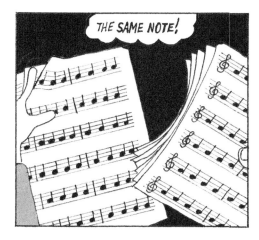
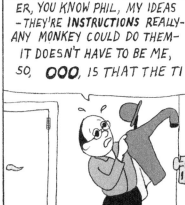

Referenced here are a couple of minimalists and a film; the composer Philip Glass, the visual artist Sol LeWitt, and a film. Much of Sol LeWitt's work consists of sets of instructions for wall drawings, leaving it for other people to execute. In a certain film Jack Nicholson's wife finally gets to see the manuscript her writer husband has been working on. It's the same sentence repeated over and over. Very dull reading. I can't really remember but I think she yawns and that's the end.

Gilbert and Georg Baselitz

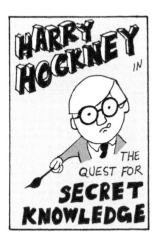

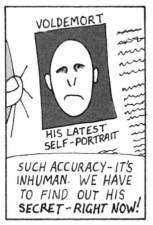

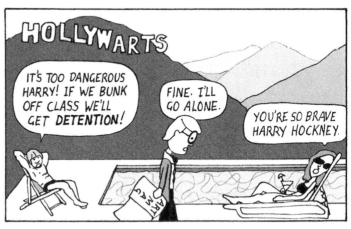

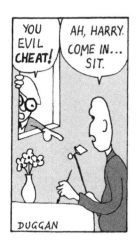

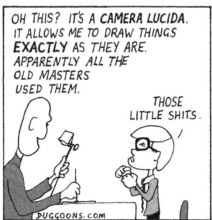

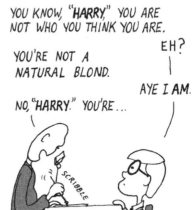

GEORGES BRAQUE REMINISCES ABOUT INVENTING **CUBISM** WITH **PABLO PICASSO**

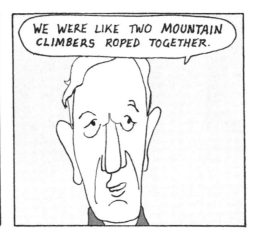

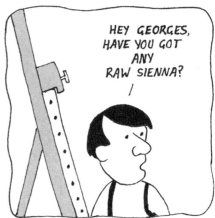

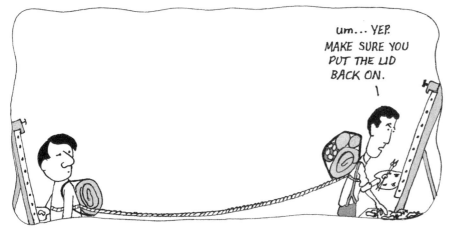

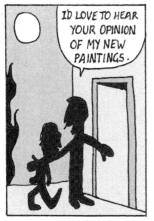

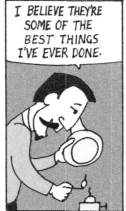

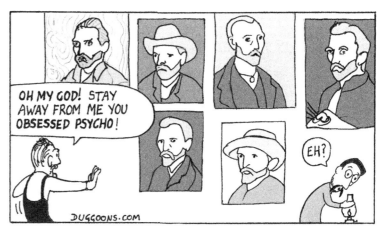

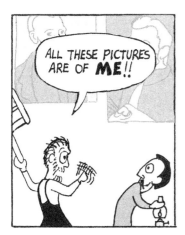

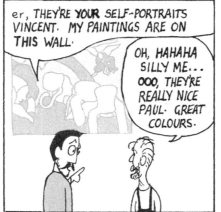

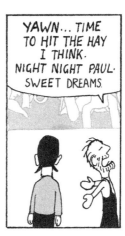

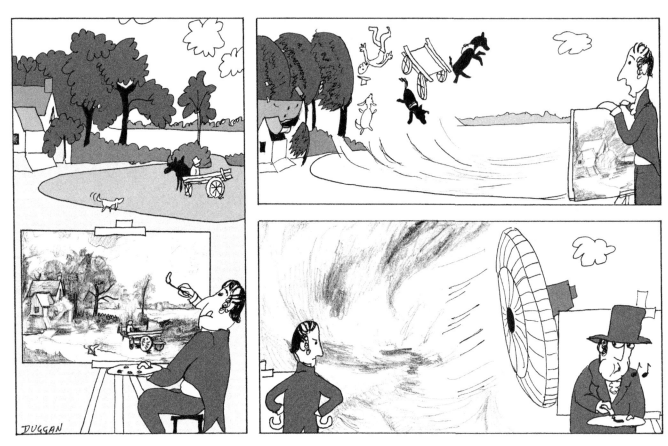

Constable and Turner's relationship was best described as passive aggressive.

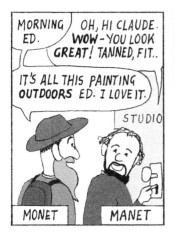

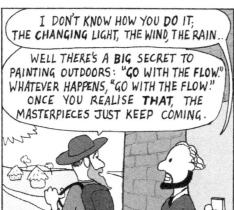

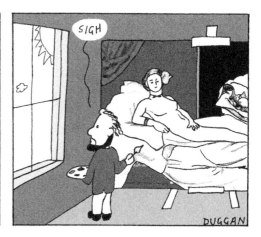

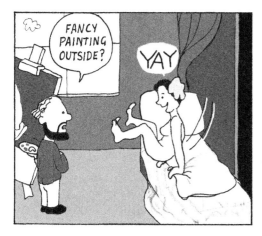

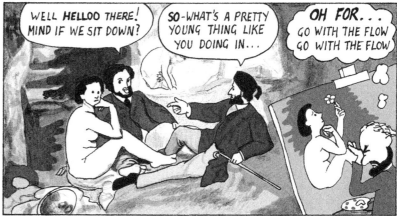

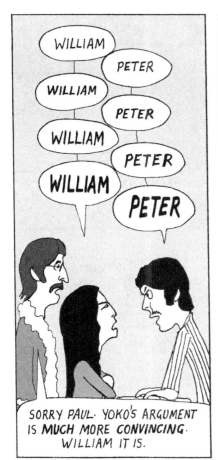

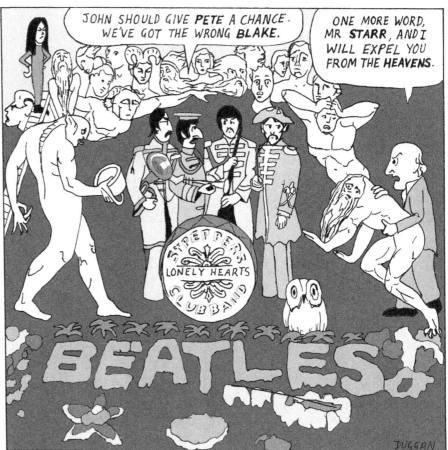

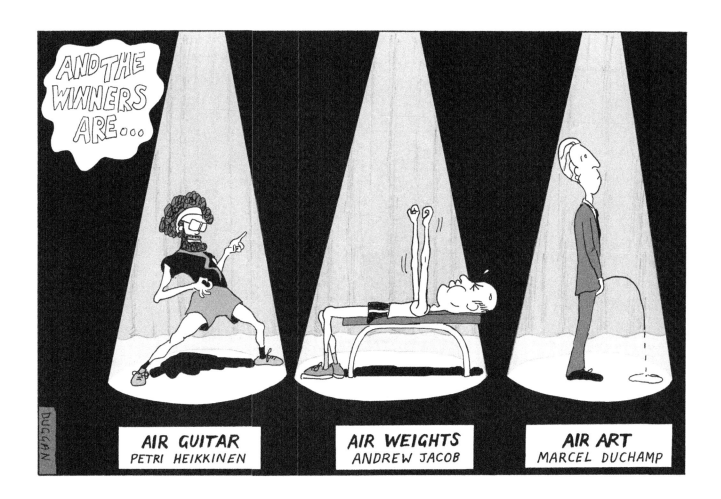

Duchamp helped found the Society of Independent Artists in New York, with its promise to never exclude the art of anyone who entered. In the 1917 inaugural exhibition Duchamp submitted a urinal under the pseudonym R. Mutt. He called it *Fountain* (brilliant). It was excluded. The mischievous Duchamp then resigned as head of the Hanging Committee in apparent disgust. Cue art world scandal. I am inordinately fond this cartoon for several reasons: in much the same way as *Fountain*, it comically obliges the viewer to ponder the nature of art; also, I put my friend Andrew Jacob in it; and finally, it immortalises a man who must never be forgotten – in 1996, at the very first Air Guitar World Championships, Petri Heikkinen came third.

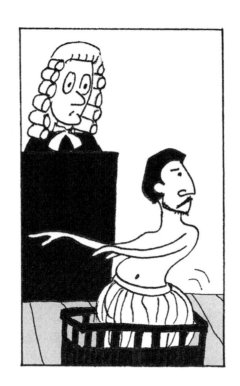

ART AND THE STATE

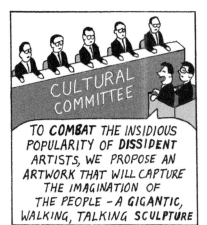

CULTURAL COMMITTEE

TO **COMBAT** THE INSIDIOUS POPULARITY OF **DISSIDENT** ARTISTS, WE PROPOSE AN ARTWORK THAT WILL CAPTURE THE IMAGINATION OF THE PEOPLE – A GIGANTIC, WALKING, TALKING SCULPTURE

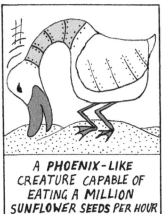

A **PHOENIX-LIKE** CREATURE CAPABLE OF EATING A **MILLION** SUNFLOWER SEEDS PER HOUR

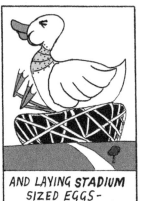

AND LAYING **STADIUM** SIZED EGGS – MADE OF **GOLD!**

I ALWAYS PAY MY FAIR SHARE.

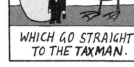

WHICH GO STRAIGHT TO THE **TAXMAN.**

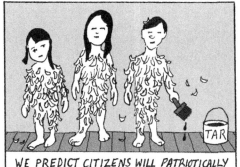

TAR

WE PREDICT CITIZENS WILL PATRIOTICALLY SHOW THEIR SUPPORT BY POSTING **PHOTOS** OF THEMSELVES **ONLINE** DRESSED AS "**THE PEKING DUCK.**"

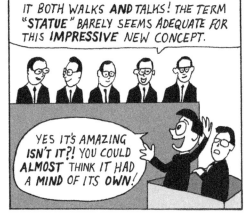

IT BOTH WALKS **AND** TALKS! THE TERM "**STATUE**" BARELY SEEMS ADEQUATE FOR THIS **IMPRESSIVE** NEW CONCEPT.

YES IT'S AMAZING **ISN'T IT?!** YOU COULD **ALMOST** THINK IT HAD A MIND OF ITS **OWN!**

ROBOT! ROBOT! HE MEANT ROBOT!

DUGGAN

Although both undepicted and unmentioned, the subject of this cartoon is Ai Weiwei. He helped design the famous bird's nest stadium of the 2008 Beijing Olympic Games. His 2010 commission for Tate Modern's Turbine Hall was millions of handcrafted porcelain sunflower seeds. But he is mostly known for criticising the Chinese government's stance on human rights and democracy. Consequently he was done up on charges of tax evasion and pornography, prompting many to show their support by posting nude pictures of themselves. The cartoon is my version of an "official" anti-Ai Weiwei response. After publication in The Guardian it appeared on Ai Weiwei's twitter feed.

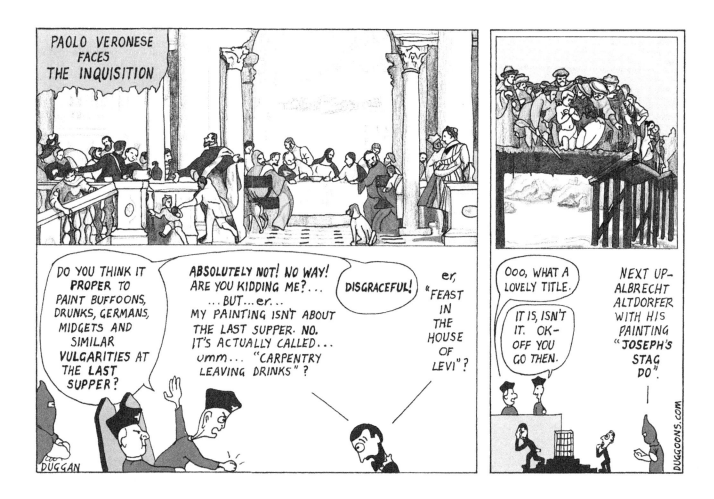

This actually happened. Veronese was hauled before the Inquisition (the Inquisitor's speech is verbatim) but he simply changed the title and got away with it. The reference to Germans was due to Martin Luther and those other pesky Germans who started the Reformation. My worry with the second panel was that I wouldn't be able to find a painting that came across clearly enough, especially as it was such a small section of the cartoon. Luckily I found this Altdorfer, *The Martyrdom of St Florian* (he was dumped into a river with a millstone around his neck). It is a masterpiece of graphic clarity.

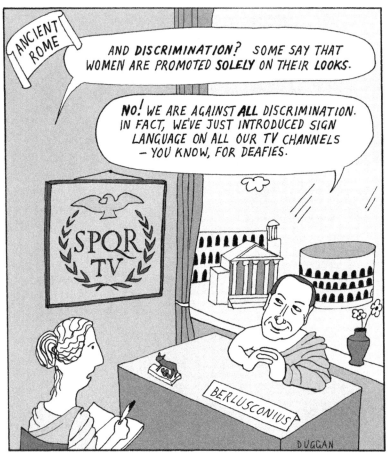

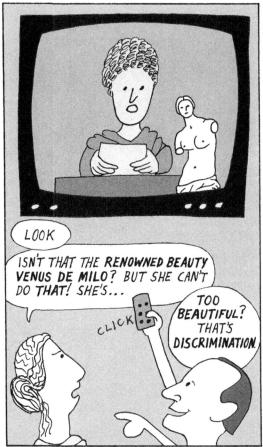

As well as controlling most of the country's media, Silvio Berlusconi was Prime Minister of Italy 4 times. While doing all of this he also built a formidable reputation for liking the ladies. Time management skills like this are rare.

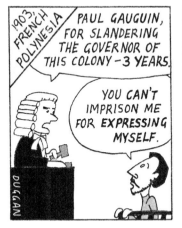

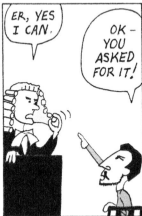

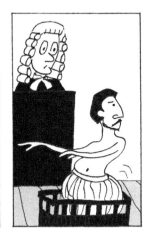

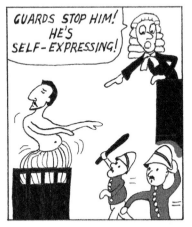

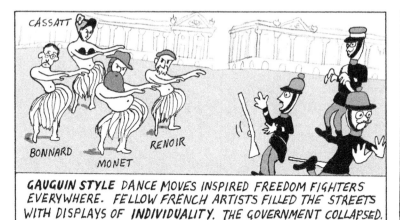

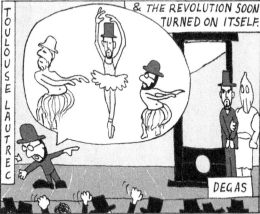

Gangnam Style, a song by Psy, took over the world for a while in 2012. The Chinese artist Ai Weiwei co-opted the song to make a point about censorship and oppression. A lot of other artists then followed suit in support. But did you know a similar thing happened over a hundred years before with Gauguin Style? Neither did I until I drew it. It just seems to be the way with revolutions – they change things, then brutally enforce the new orthodoxy. The new way often ends up more oppressive than the one it replaced. That's what is happening here with Toulouse-Lautrec and Degas, who continue their (entirely fictitious) antagonistic relationship in my cartoons. Love those guys.

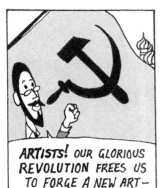

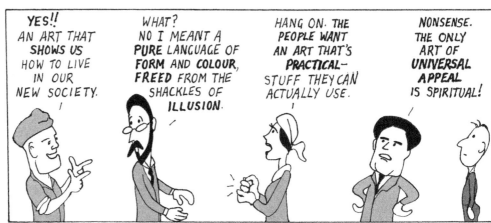

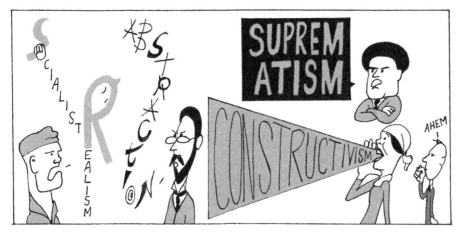

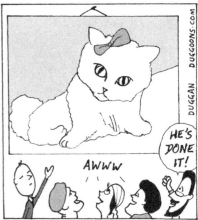

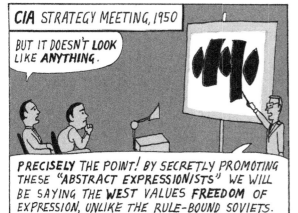

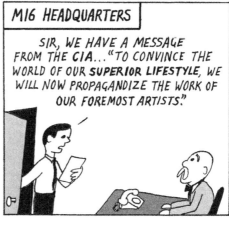

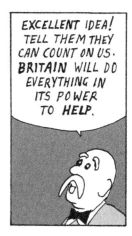

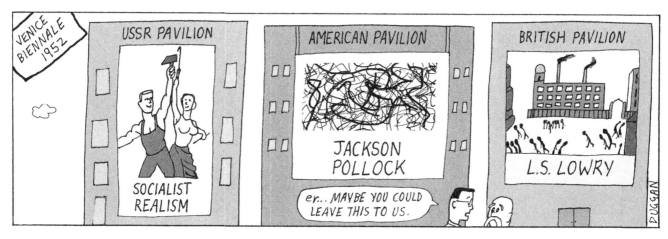

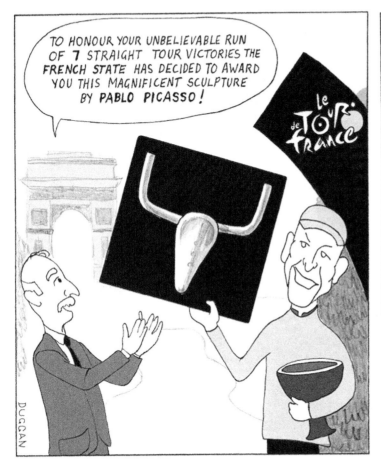
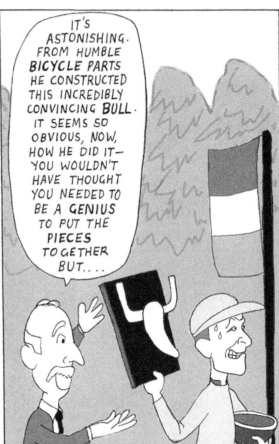

For seven years Lance Armstrong was on fire. And drugs.

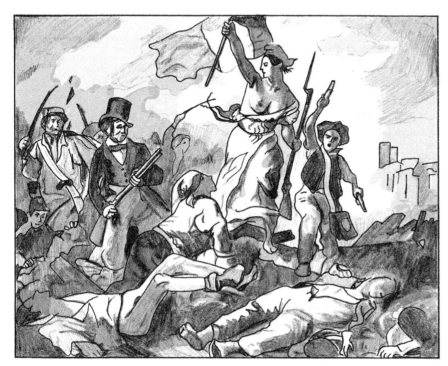 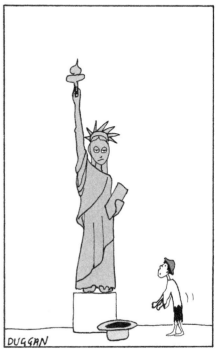

People remember Liberty Leading the People mainly for the "incident".
Liberty herself always insisted it wasn't a publicity stunt but a wardrobe
malfunction. However, her career was ruined and eventually she became a busker.

Janet Jackson didn't get nearly as much blowback.

 Publius Horatius
5 seconds ago

Me and my bros about to fight some other dudes to the death to save our city... **OMFG!**

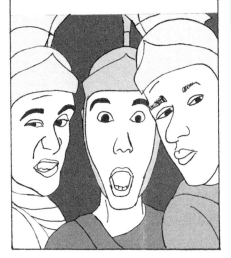

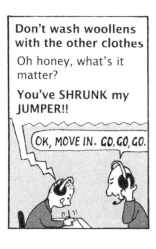

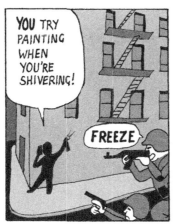

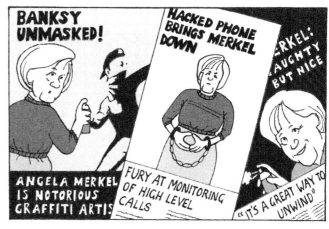

U.S. SENATE INQUIRY INTO N.S.A.

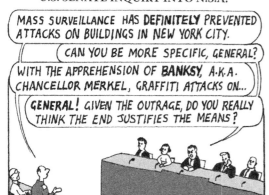

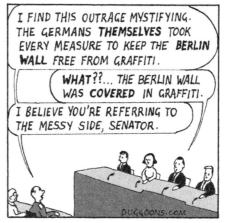

I drew this cartoon just as the news broke that the US government, specifically the National Security Agency, was secretly eavesdropping on the phone calls of all citizens. It was also around the time when Banksy spent a month in New York, doing his trademark graffiti in a different place each night. There was also 9/11.

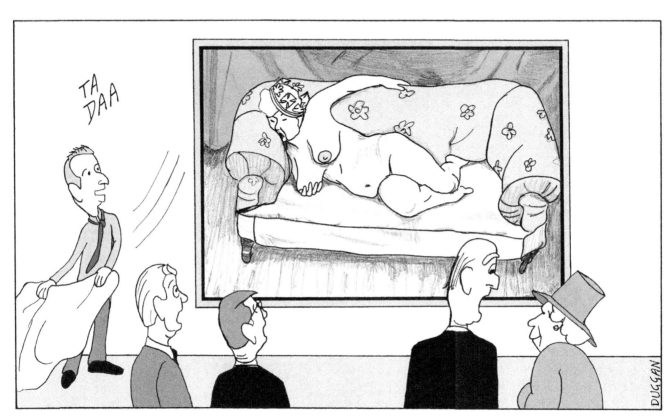

Lucian Freud's first version of the Queen was rejected
by the Palace.

The blame for this book lays squarely at the feet of my friends Al and Jane. One sunny London afternoon, they suggested I should think seriously about becoming a cartoonist. As I was not in the habit of drawing cartoons, it struck me as an absurd idea, but they persisted, arguing that since I was torn between a love of painting and a habit of making short comic films – basically between imagery and telling funny stories – cartooning might be a happy medium. I could draw my films, and in much less time. Put that way it made sense, so I had a crack at it. Some of those first cartoons were deeply strange (a flat head lying on a pavement after knocking over a fence?) but I was encouraged enough to continue, particularly by one about Jackson Pollock. Crafting and refining a joke is a great mental pleasure, that much I already knew, but with that cartoon it began to dawn on me that the art world could be a cartoonist's goldmine - a place where the banalities of life collide with a day job creating masterpieces, inhabitated by the bonkers and the brilliant, and with more isms than you could poke a brick at. Importantly, it was also a world in which my head was thoroughly soaked.

Once I had drawn what I felt were five pretty funny art cartoons, I sent them out to some art magazines – their natural home I thought. No bites. In an act of desperation I sent them off to a few of the quality, broadsheet newspapers. Within a couple of days the online division of The Guardian got in touch. "These are great! Can we see some more?" Er, no. "Would you like to do a weekly strip?" "Sure" I said, rapidly filling my nappy.

In the steep and very public learning curve that followed, The Guardian gave me the odd bit of advice ("Can we have something uber-famous this week – nothing too niche?") but basically left me to my own devices, allowing me to make up the rules as I went along. A fantastic, dream job, for which I am eternally grateful.

A sizeable chunk of Western art is about religion, so it should be no surprise to find it's haloed head rearing up in my cartoons every so often. The intention is always to amuse, rarely to offend, but if you feel I have overstepped the mark I would say that where that mark lies is very subjective. The only way to get some degree of objectivity is to buy five or more copies, give them to your friends and see where the consensus lies.

If you feel you are missing a reference, don't worry! I have helpfully placed, not one, but two indexes at the back of this book. The first is by page number, listing the artists and artworks appearing on each page. The second index is by artist name, so you can find jokes about your favourite artists. If necessary, combine with Google for some newly-enlightened mirth.

Finally, I would like to thank my editors at The Guardian online; Andrew Dickson for his momentary lapse of reason in giving me the gig in the first place, and Kate Abbott, who only occasionally had to tell me I had overstepped the mark. But mostly I'd like to thank my lovely wife Grace for being such an honest first reader. "No darling, it's actually hilarious" was a common refrain of mine as I tried to make her see sense, only to realise that she was the one seeing it. So this book is for her, as well as our daughter Zoe, who is, in the immortal words of a great landscape painter, simply the best.

INDEX BY PAGE

41 **Edward Hopper**: Early Sunday Morning (1930); **Hans Holbein the Younger**: The Ambassadors (1533); **Chris Burden**: Shoot (performance – 1971); **Marcel Duchamp**: The Bride Stripped Bare by her Bachelors, Even (The Large Glass) (1915-1923)

42 **Robert Indiana**: Love (1970)

43 **Damien Hirst**

44 **Caravaggio**: The Entombment of Christ (1603-1604), **Derek Jarman**: Caravaggio (Film, 1986)

45 **Julian Schnabel**: The Diving Bell and the Butterfly (movie – 2007)

46 **Edward Hopper**: Early Sunday Morning (1930): **Mark Rothko**

47 **Leonardo Da Vinci**: Madonna Litta (1490-1491)

48 **Jan Van Eyck**: The Arnolfini Portrait (1434)

49 **Tracey Emin**

50 **Cy Twombly**

51 **Gary Hume**: Four Doors (1) (1989-1990); **Michael Craig-Martin**; **Damien Hirst**; **Sarah Lucas**: Self-Portrait with Fried Eggs (1996)

52 **Anthony Van Dyck**: Christ Crucified with the Virgin, Saint John and Mary (1628-1630); **David Shrigley**: I'm Dead (2010)

53 **Antony Gormley**: Another Place (1997), Event Horizon (2007)

54 **Adriaen van Utrecht**: Vanitas: Still Life with Bouquet and Skull (c. 1642); **Andy Warhol**; **Theodore Gericault**: Anatomical Fragments (1818)

55 **Arcimboldo**: Vertumnus (c.1590-1591); Mr Potatohead; **Elias Garcia Martinez**: Ecce Homo (c. 1930); **Cecilia Giminez**: Ecce Homo (2012)

56 **Eadweard Muybridge**: Animal Locomotion, Plate 197 (Dancing Couple) (1887)

57 **Martin Creed**: Work No. 227: The lights going on and off (2001)

58 **Michelangelo**: David (1501-1504)

59 **Theodore Gericault**: The Raft of Medusa (1818-1819)

60 **Damien Hirst**

61 Frieze Art Fair, London; **Gerhard Richter**; **Richard Prince**; **Ron Mueck**; **Anselm Kiefer**; **Jake and Dinos Chapman**

62 **Jasper Johns**

63 **Henry Fuseli**: The Nightmare (1781); **Allen Jones**: Table (1969), Chair (1969)

64 **Andy Warhol**: Campbell's Soup I (1968); **Edvard Munch**: The Scream (1893)

65 **Jackson Pollock**

66 **Diego Velazquez**: Las Meninas (1656)

68 **Jackson Pollock; Clement Greenberg**

69 **Pablo Picasso**: Les Demoiselles d'Avignon (1907)

70 **Alain de Botton** and **John Armstrong**: Art As Therapy (book – 2013); **Frans Hals**: The Laughing Cavalier (1624)

71 **Andrea Mantegna**: Camera degli Sposi (1465-1474)

72 **Gustave Courbet**: Bonjour Monsieur Courbet (1854); **John Constable**: The Hay Wain (1821)

73 **Jasper Johns**: Flag (1954-55), Target (1961), Map (1961)

74 **Damien Hirst**: Verity (2012); **Apollonios**: The Belvedere Torso (1st century BCE)

75 **Henri Rousseau**: The Sleeping Gypsy (1897); **Peter Paul Rubens**: The Lion Hunt (1621)

76 **Edouard Manet**: Olympia (1863), A Bar at the Folies-Bergere (1882), The Luncheon on the Grass (1862-1863)

77 **Roy Lichtenstein**: Drowning Girl (1963)

78 **Vincent Van Gogh**: The Potato Eaters (1885), The Night Cafe (1888), The Starry Night (1889); **Andy Warhol**; **Arthur Sarnoff**: The Hustler (c. 1950); **Jasper Johns**; Flag (1954-1955); **Robert Indiana**: Love (1970)

79 **Alain de Botton** and **John Armstrong**: Art As Therapy (book – 2013); **Andy Warhol**: Triple Elvis (1963); **Roy Lichtenstein**: In the Car (1963)

80 **Luigi Russolo**: The Revolt (1911); **Umberto Boccioni**: The City Rises (1910), Unique Forms of Continuity in Space (1913)

81 **Leonardo da Vinci**: The Last Supper (1495-1498)

84 **Gustav Klimt**: The Kiss (1907-1908)

INDEX BY ARTIST

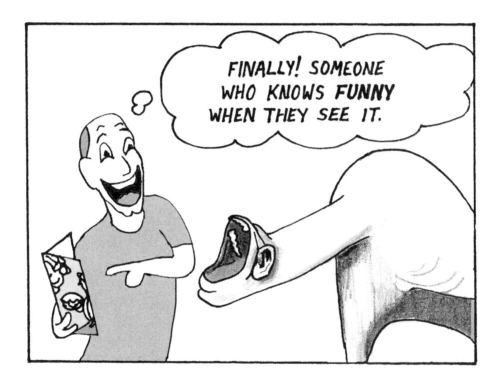

Hailing from Sydney, Australia, Peter Duggan likes to draw cartoons about art as well as making it.
He has written and directed several award winning comic short films, and is also the cartoonist
behind Walnuts, a parody of Peanuts featuring the Trump administration.
Peter publishes his own line of greeting cards under the name Duggoons.

His website is duggoons.com.

Printed in Great Britain
by Amazon

35243118R00084